Dedalus European Classics

General Editor: David Blow

Dedalus / Hippocrene

VOLTAIRE

MICROMEGAS
(and other stories)

translated by W. Fleming

with an introduction and chronology by
Ben Barkow

Dedalus / Hippocrene

Published in the UK by Dedalus Ltd,
Langford Lodge, St Judith's Lane, Sawtry, Cambs, PE17 5XE
Published in the USA by Hippocrene Books Inc.,
171 Madison Avenue, New York NY10016

ISBN 0 946626 55 3

First published in France in 1752–68
Dedalus edition 1989

Introduction copyright © Dedalus 1989

Printed in Great Britain by
Richard Clay Ltd, Bungay, Suffolk

A CIP listing for this title is available on request

LIST OF CONTENTS

Introduction

Size, the worried man is told, is not everything. In *Micromegas*, Voltaire's extraordinary meditation on the little and the large, such consolations are put to the test. Is biggest best? Is a giant from another world, superendowed with a thousand senses and an almost endless life-span, essentially better than a man? Or is a microscopically small creature, unburdened in its physical make-up by gross matter, in some way more spiritual and ethereal than, say, a dwarf from Saturn? Do tiny things have souls (interesting question, this; numerous writers have been exercised over it, including E. M. Forster in *A Passage to India*)? And does travel, be it across vast tracts of space or more locally to the North Pole, really broaden the mind?

And what about science; is it a good thing? Does the discovery of new realms of existence alter the human condition? Does the ability to measure and weigh with precision have intrinsic worth, or is it merely the kind of thing with which to make an impression on a passing alien? Like many works of art, *Micromegas* poses more questions than it answers.

In all probability Voltaire wrote his philosophical tale in or around 1738. Originally known as *The Adventures of Baron Gangan*, the manuscript was sent to Frederick

II of Prussia, who liked it but lost it. For reasons that remain unclear Voltaire only completed and published the tale in 1752 when he was at Frederick's court. To add to the confusion, the early editions of the book were published in London, rather than Berlin or Paris.

Some time around 1728/9 Voltaire returned to France from a three year exile in England, the result of a quarrel with the Duc de Rohan which had also landed him in the Bastille. In England he was impressed by the prevailing atmosphere of religious tolerance. He became acquainted with the work of Sir Isaac Newton (whose funeral he attended in 1727) and John Locke, in which he detected the future course of science and philosophy. He determined, on his return to France, to study science and philosophy in depth. He also read widely in English literature and met many leading figures such as Alexander Pope and Jonathan Swift (whose *Gulliver's Travels* served as a model for *Micromegas*).

Voltaire devoted several years to a systematic study of science, in particular astronomy, physics and philosophy. He read Galileo, Newton, Huygens, Francis Bacon, Descartes and his great populariser Bernard de Fontenelle. He also took a lively interest in the work of microscopists Anton Leeuwenhoek and Robert Hooke. Although he never became a scientist of any standing, being too impatient with experiments which failed to produce the results he wanted, he did become competent as a scientific commentator and populariser. In 1733 he published his *Letters Concerning the English*

Nation (issued in France the following year as *Lettres Philosophiques*). This was a highly controversial book in France, where it was publicly burned and a warrant for the author's arrest issued. In it he highlighted the extent to which France had fallen behind England in matters of science and philosophy, and introduced Newtonian and Lockean ideas. By doing so he was establishing a claim as the leader of the pro-Newton, anti-Descartes camp. By 1738, when he published his *Elements de la Philosophie de Newton*, this position was undisputed. He had declared war on the cartesian system of cosmology and on its defenders, led by Fontenelle.

It was against this background of scientific controversy that *Micromegas* was written. In it Voltaire ruthlessly satirises Fontenelle's ideas and the absurdities they lead to. Thus, Fontenelle's belief that the size of a star determines the relative size, life-span and number of senses of whatever lives in its vicinity is ridiculed in the figure of Micromegas. Similarly, Micromegas' elaborate mode of speech mocks Fontenelle's florid language. The expedition which Micromegas meets parodies Pierre de Maupertuis, Voltaire's rival at Frederick's court, who had undertaken a voyage to the North Pole in order to determine the true shape of the earth (flattened at the poles). Yet even here the last laugh is on Fontenelle, because Maupertuis' findings tended to support the Newtonian doctrine against Descartes. Another target for Voltaire's satire is what he regarded as the absurd Christian doctrine that the

universe is made solely for the good of mankind. The notions of Leibniz and Rousseau that this is the best of all possible worlds are also attacked (although he would wait until after the Lisbon earthquake in 1755 before he really went to work on these ideas), as is the presumption that science holds the only key to understanding the marvels of the world.

A word about the form of *Micromegas*. It is a conte philosophique, a philosophical tale. This is a form more or less invented by Voltaire. It takes as its starting point the ancient genre of the imaginary voyage (examples include Rabelais' *Gargantua* and Swift's *Gulliver*), which allows Voltaire to invent a plot in defiance of all plausibility. However, unlike most of these works, Voltaire's story is short and very direct (while he admired *Gulliver* and borrowed from it he also thought it too long, dull and overstuffed with incident). By telling the story from the space travellers' perspective Voltaire explodes the convention of the literary utopia, freeing it for satirical purposes. Neither for the visitors nor for the earthlings is there anything utopian or ideal.

Voltaire is not altogether optimistic about life on earth. He sees as inescapable the evils of war, tyranny and social injustice. Mankind is not infinitely improvable, as some thinkers of the day were suggesting. And yet there is much to be grateful for and to take pleasure in. The wise man maintains a sense of humour and a willingness to make the most of life. The message of *Micromegas*, if it has one, is that there is more to life

than any one system of thought, be it science or Christianity or whatever, can comprehend. What we all need is a sense of proportion, of what matters and what is trivial or ridiculous. The fundamental lesson we must learn is that the world is not made for us alone. When this is understood there is some hope of progress in human understanding.

BEN BARKOW

Ben Barkow studied at Middlesex Polytechnic and University College London before working for four years at the Wellcome Institute for the History of Medicine. He is now a freelance researcher and his current projects include a biographical dictionary of over-achievers.

CHRONOLOGY

1694 Francois-Marie Arouet (Voltaire) born on 21 November.

1703 Voltaire enters Jesuit college Louis-le-Grand in October.

1704 Newton publishes his *Optics*.

1711 Voltaire leaves Louis-le-Grand.

1712 Rousseau born.

1713 Voltaire in Holland as secretary to the French Ambassador. Diderot born.

1714 He begins to study law.

1715 Louis XI dies. Regency of Philippe d'Orleans begins.

1716 Leibniz dies.

1717 D'Alembert born. Voltaire is imprisoned for 11 months for composing a satire against the Regent.

1718 Assumes pen-name Voltaire. His first play, *Oedipe* has its premiere on 18 November.

1726 Voltaire quarrels with the Chevalier de Rohan. As a result he is imprisoned again and later forced into exile. He travels to England.

1727 Death of Newton in April.

1728 Publication of *La Henriade* in March.

1729 Returns to Paris.

1731 He publishes his *Histoire de Charles XII*.

1733	Alexander Pope publishes his *Essay on Man*. Voltaire meets and befriends Mme du Chattelet. He publishes *Letters Concerning the English Nation*, issued in France as *Lettres Philosophiques*.
1738	He publishes his *Elements de la Philosophie de Newton*.
1739	Writes early version of *Micromegas*.
1740	Frederick the Great becomes King of Prussia. Voltaire joins his court in Potsdam.
1741	First performance of *Mahomet*.
1744	Death of Alexander Pope. Louis XV declares war on Austria and England.
1745	Voltaire is appointed Historiographer of France.
1746	He is elected to the Académie Française.
1747	Diderot and D'Alembert initiate work on their *Encyclopédie*, the first modern encyclopedia. Voltaire contributes numerous articles. *Zadig* appears in Holland.
1750	He goes to Prussia to take up an appointment as Chamberlain to Frederick II.
1749	Death of Mme du Chattelet.
1751	First volume of *Encyclopédie* is published.
1752	First publication of *Micromegas*. The *Encyclopédie* is officially condemned.
1753	Voltaire leaves Prussia after disagreements with Frederick.
1754	Rousseau publishes *Discours sur l'inégalité*. Voltaire goes to Geneva.

1755 Earthquake in Lisbon on 1 November. Voltaire finishes his *Poème sur le désastre de Lisbonne* in December.

1756 Start of Seven Years War as Frederick II invades Saxony.

1758 D'Alembert stops work on the *Encyclopédie*.

1759 Voltaire publishes *Candide*.

1762 Rousseau publishes *Emile* and *Du contrat social*.

1764 Voltaire publishes his *Dictionnaire Philosophique*.

1765 The *Encyclopédie* is again published.

1772 The last volumes of the *Encyclopédie* are issued.

1774 Louis XV dies and is succeeded by Louis XVI.

1775 *Le Barbier de Séville* by Beaumarchais appears.

1778 Rousseau dies. Voltaire dies on 30 May.

MICROMEGAS.

CHAPTER I.

A VOYAGE TO THE PLANET SATURN BY A NATIVE OF SIRIUS.

In one of the planets that revolve round the star known by the name of Sirius was a certain young gentleman of promising parts, whom I had the honor to be acquainted with in his last voyage to this our little ant-hill. His name was Micromegas, an appellation suited to all great men, and his stature amounted to eight leagues in height, that is, twenty-four thousand geometrical paces of five feet each.

Some of your mathematicians, a set of people always useful to the public, will perhaps instantly seize the pen and calculate that Mr. Micromegas, inhabitant of the country of Sirius, being from head to foot four and twenty thousand paces in length, making one hundred and twenty thousand royal feet, that we, denizens of this earth, being at a medium little more than five feet high, and our globe nine thousand leagues in circumference; these things being premised, they will then conclude that the periphery of the globe which produced him must be exactly one and twenty millions six hundred thousand

times greater than that of this, our tiny ball. Nothing in nature is more simple and common. The dominions of some sovereigns of Germany or Italy, which may be compassed in half an hour, when compared with the Ottoman, Russian, or Chinese empires, are no other than faint instances of the prodigious difference that nature has made in the scale of beings. The stature of his excellency being of these extraordinary dimensions, all our artists will agree that the measure around his body might amount to fifty thousand royal feet, a very agreeable and just proportion.

His nose being equal in length to one-third of his face, and his jolly countenance engrossing one-seventh part of his height, it must be owned that the nose of this same Sirian was six thousand three hundred and thirty-three royal feet, to a hair, which was to be demonstrated. With regard to his understanding, it is one of the best cultivated I have known. He is perfectly well acquainted with abundance of things, some of which are of his own invention; for, when his age did not exceed two hundred and fifty years, he studied according to the custom of the country, at the most celebrated university of the whole planet, and by the force of his genius discovered upwards of fifty propositions of Euclid, having the advantage by more than eighteen of Blaise Pascal, who (as we are told by his own sister), demonstrated two and thirty for his amusement and then

left off, choosing rather to be an indifferent philos-
opher than a great mathematician.

About the four hundred and fiftieth year of his age,
or latter end of his childhood, he dissected a great
number of small insects not more than one hundred
feet in diameter, which are not perceivable by ordi-
nary microscopes, on which he composed a very cu-
rious treatise, which involved him in some trouble.
The mufti of the nation, though very old and very
ignorant, made shift to discover in his book certain
lemmas that were suspicious, unseemly, rash, heretic,
and unsound, and prosecuted him with great animos-
ity; for the subject of the author's inquiry was
whether, in the world of Sirius, there was any differ-
ence between the substantial forms of a flea and a
snail.

Micromegas defended his philosophy with such
spirit as made all the female sex his proselytes; and
the process lasted two hundred and twenty years;
at the end of which time, in consequence of the
mufti's interest, the book was condemned by judges
who had never read it, and the author expelled from
court for the term of eight hundred years.

Not much affected at his banishment from a court
that teemed with nothing but turmoils and trifles,
he made a very humorous song upon the mufti, who
gave himself no trouble about the matter, and set out
on his travels from planet to planet in order (as the
saying is) to improve his mind and finish his educa-
tion. Those who never travel but in a post-chaise or

berlin, will doubtless be astonished at the equipages used above, for we that strut upon this little mole-hill are at a loss to conceive anything that surpasses our own customs. But our traveller was a wonderful adept in the laws of gravitation, together with the whole force of attraction and repulsion, and made such seasonable use of his knowledge that sometimes by the help of a sunbeam, and sometimes by the convenience of a comet, he and his retinue glided from sphere to sphere, as the bird hops from one bough to another. He in a very little time posted through the milky way, and I am obliged to own he saw not a twinkle of those stars supposed to adorn that fair empyrean which the illustrious Dr. Derham brags to have observed through his telescope. Not that I pretend to say the doctor was mistaken. God forbid! But Micromegas was upon the spot, an exceeding good observer, and I have no mind to contradict any man. Be that as it may, after many windings and turnings, he arrived at the planet Saturn, and, accustomed as he was to the sight of novelties, he could not for his life repress a super-cilious and conceited smile, which often escapes the wisest philosopher, when he perceived the small-ness of that globe and the diminutive size of its inhabitants; for really Saturn is but about nine hundred times larger than this our earth, and the people of that country mere dwarfs, about a thousand fathoms high. In short, he at first derided those poor pygmies, just as an Indian fiddler laughs at the

music of Lully, at his first arrival in Paris; but as this Sirian was a person of good sense, he soon perceived that a thinking being may not be altogether ridiculous, even though he is not quite six thousand feet high; and therefore he became familiar with them, after they had ceased to wonder at his extraordinary appearance. In particular, he contracted an intimate friendship with the secretary of the Academy of Saturn, a man of good understanding, who, though in truth he had invented nothing of his own, gave a very good account of the inventions of others, and enjoyed in peace the reputation of a little poet and great calculator. And here, for the edification of the reader, I will repeat a very singular conversation that one day passed between Mr. Secretary and Micromegas.

CHAPTER II.

THE CONVERSATION BETWEEN MICROMEGAS AND THE INHABITANT OF SATURN.

His excellency having laid himself down, and the secretary approached his nose:

"It must be confessed," said Micromegas, "that nature is full of variety."

"Yes," replied the Saturnian, "nature is like a parterre, whose flowers—"

"Pshaw!" cried the other, "a truce with your parterres."

"It is," resumed the secretary, "like an assembly of fair and brown women, whose dresses—"

"What a plague have I to do with your brunettes?" said our traveller.

"Then it is like a gallery of pictures, the strokes of which—"

"Not at all," answered Micromegas, "I tell you, once for all, nature is like nature, and comparisons are odious."

"Well, to please you," said the secretary—

"I won't be pleased," replied the Sirian, "I want to be instructed; begin, therefore, without further preamble, and tell me how many senses the people of this world enjoy."

"We have seventy and two," said the academician, "but we are daily complaining of the small number, as our imagination transcends our wants, for, with the seventy-two senses, our five moons and ring, we find ourselves very much restricted; and notwithstanding our curiosity, and the no small number of those passions that result from these few senses, we have still time enough to be tired of idleness."

"I sincerely believe what you say," cried Micromegas, for, though we Sirians have near a thousand different senses, there still remains a certain vague desire, an unaccountable inquietude incessantly admonishing us of our own unimportance, and giving us to understand that there are other beings who are much our superiors in point of perfection. I

have travelled a little, and seen mortals both above and below myself in the scale of being, but I have met with none who had not more desire than necessity, and more want than gratification. Perhaps I shall one day arrive in some country where naught is wanting, but hitherto I have had no certain information of such a happy land."

The Saturnian and his guest exhausted themselves in conjectures upon this subject, and after abundance of argumentation equally ingenious and uncertain, were fain to return to matter of fact.

"To what age do you commonly live?" said the Sirian.

"Lackaday! a mere trifle," replied the little gentleman.

"It is the very same case with us," resumed the other, the shortness of life is our daily complaint, so that this must be a universal law in nature."

"Alas!" cried the Saturnian, "few, very few on this globe outlive five hundred great revolutions of the sun (these, according to our way of reckoning, amount to about fifteen thousand years). So, you see, we in a manner begin to die the very moment we are born; our existence is no more than a point, our duration an instant, and our globe an atom. Scarce do we begin to learn a little, when death intervenes before we can profit by experience. For my own part, I am deterred from laying schemes when I consider myself as a single drop in the midst of an immense ocean. I am particularly ashamed, in

your presence, of the ridiculous figure I make among my fellow-creatures."

To this declaration Micromegas replied:

"If you were not a philosopher, I should be afraid of mortifying your pride by telling you that the term of our lives is seven hundred times longer than the length of your existence; but you are very sensible that when the texture of the body is resolved, in order to reanimate nature in another form, which is the consequence of what we call death— when that moment of change arrives, there is not the least difference betwixt having lived a whole eternity or a single day. I have been in some countries where the people live a thousand times longer than with us, and yet they murmured at the shortness of their time. But one will find everywhere some few persons of good sense, who know how to make the best of their portion and thank the author of nature for his bounty. There is a profusion of variety scattered through the universe, and yet there is an admirable vein of uniformity that runs through the whole; for example, all thinking beings are different among themselves, though at bottom they resemble one another in the powers and passions of the soul. Matter, though interminable, hath different properties in every sphere. How many principal attributes do you reckon in the matter of this world?"

"If you mean those properties," said the Saturnian, "without which we believe this our globe

could not subsist, we reckon in all three hundred, such as extent, impenetrability, motion, gravitation, divisibility, et cætera."

"That small number," replied the traveller, "probably answers the views of the Creator on this your narrow sphere. I adore His wisdom in all His works. I see infinite variety, but everywhere proportion. Your globe is small, so are the inhabitants. You have few sensations, because your matter is endued with few properties. These are the works of unerring providence. Of what color does your sun appear when accurately examined?"

"Of a yellowish white," answered the Saturnian, "and in separating one of his rays we find it contains seven colors."

"Our sun," said the Sirian, "is of a reddish hue, and we have no less than thirty-nine original colors. Among all the suns I have seen there is no sort of resemblance, and in this sphere of yours there is not one face like another."

After divers questions of this nature he asked how many substances, essentially different, they counted in the world of Saturn, and understood that they numbered but thirty, such as God, space, matter, beings endowed with sense and extension, beings that have extension, sense, and reflection; thinking beings who have no extension; those that are penetrable; those that are impenetrable, and also all others. But this Saturnian philosopher was prodigiously astonished when the Sirian told him they

had no less than three hundred, and that he himself had discovered three thousand more in the course of his travels. In short, after having communicated to each other what they knew, and even what they did not know, and argued during a complete revolution of the sun, they resolved to set out together on a small philosophical tour.

CHAPTER III.

THE VOYAGE OF THESE INHABITANTS OF OTHER WORLDS.

Our two philosophers were just ready to embark for the atmosphere of Saturn, with a large provision of mathematical instruments, when the Saturnian's mistress, having got an inkling of their design, came all in tears to make her protests. She was a handsome brunette, though not above six hundred and threescore fathoms high; but her agreeable attractions made amends for the smallness of her stature.

"Ah! cruel man," cried she, "after a courtship of fifteen hundred years, when at length I surrendered and became your wife, and scarce have passed two hundred more in thy embraces, to leave me thus, before the honeymoon is over, and go a-rambling with a giant of another world! Go, go, thou art a mere virtuoso, devoid of tenderness and love! If thou wert a true Saturnian, thou wouldst be faithful

and invariable. Ah! whither art thou going? what is thy design? Our five moons are not so inconstant, nor our ring so changeable as thee! But take this along with thee, henceforth I ne'er shall love another man."

The little gentleman embraced and wept over her, notwithstanding his philosophy; and the lady, after having swooned with great decency, went to console herself with more agreeable company.

Meanwhile our two virtuosi set out, and at one jump leaped upon the ring, which they found pretty flat, according to the ingenious guess of an illustrious inhabitant of this our little earth. From thence they easily slipped from moon to moon; and a comet chancing to pass, they sprang upon it with all their servants and apparatus. Thus carried about one hundred and fifty millions of leagues, they met with the satellites of Jupiter, and arrived upon the body of the planet itself, where they continued a whole year; during which they learned some very curious secrets, which would actually be sent to the press, were it not for fear of the gentlemen inquisitors, who have found among them some corollaries very hard of digestion. Nevertheless, I have read the manuscript in the library of the illustrious archbishop of ——, who, with that generosity and goodness which should ever be commended, has granted me permission to peruse his books; wherefore I promise he shall have a long article in the next edition of Moréri, and I shall not forget

the young gentlemen, his sons, who give us such pleasing hopes of seeing perpetuated the race of their illustrious father. But to return to our travellers. When they took leave of Jupiter, they traversed a space of about one hundred millions of leagues, and coasting along the planet Mars, which is well known to be five times smaller than our little earth, they descried two moons subservient to that orb which have escaped the observation of all our astronomers. I know Father Castel will write, and that pleasantly enough, against the existence of these two moons; but I entirely refer myself to those who reason by analogy. Those worthy philosophers are very sensible that Mars, which is at such a distance from the sun, must be in a very uncomfortable situation, without the benefit of a couple of moons.* Be that as it may, our gentlemen found the planet so small that they were afraid they should not find room to take a little repose, so that they pursued their journey like two travellers who despise the paltry accommodation of a village and push forward to the next market town. But the Sirian and his companion soon repented of their delicacy, for they journeyed a long time without finding a resting-place, till at length they discerned a small speck, which was the Earth. Coming from Jupiter, they could not but be moved with compassion at the sight of this miserable spot, upon which,

*This fancy of Voltaire (for it was not a conjecture) was realized in 1877 by Prof. Asaph Hall's discovery of this planet's two small satellites.

however, they resolved to land, lest they should be
a second time disappointed. They accordingly
moved toward the tail of the comet, where, finding
an aurora borealis ready to set sail, they embarked,
and arrived on the northern coast of the Baltic on
the fifth day of July, new style, in the year 1737.

CHAPTER IV.

WHAT BEFELL THEM UPON THIS OUR GLOBE.

Having taken some repose, and being desirous of
reconnoitring the narrow field in which they were,
they traversed it at once from north to south.
Every step of the Sirian and his attendants meas-
ured about thirty thousand royal feet, whereas the
dwarf of Saturn, whose stature did not exceed a
thousand fathoms, followed at a distance quite out
of breath; because, for every single stride of his
companion, he was obliged to make twelve good
steps at least. The reader may figure to himself
(if we are allowed to make such comparisons) a
very little rough spaniel dodging after a captain of
the Prussian grenadiers.

As those strangers walked at a good pace, they
compassed the globe in six and thirty hours; the
sun, it is true, or rather the earth, describes the
same space in the course of one day; but it must be
observed that it is much easier to turn upon an axis
than to walk afoot. Behold them then returned

to the spot from whence they had set out, after having discovered that almost imperceptible sea, which is called the Mediterranean, and the other narrow pond that surrounds this mole-hill, under the denomination of the great ocean, in wading through which the dwarf had never wet his mid-leg, while the other scarce moistened his heel. In going and coming through both hemispheres, they did all that lay in their power to discover whether or not the globe was inhabited. They stooped, they lay down, they groped in every corner; but their eyes and hands were not at all proportioned to the small beings that crawl upon this earth, and, therefore, they could not find the smallest reason to suspect that we and our fellow-citizens of this globe had the honor to exist.

The dwarf, who sometimes judged too hastily, concluded at once that there were no living creatures upon earth, and his chief reason was that he had seen nobody. But Micromegas, in a polite manner, made him sensible of the unjust conclusion:

"For," said he, "with your diminutive eyes you cannot see certain stars of the fiftieth magnitude, which I easily perceive; and do you take it for granted that no such stars exist?"

"But I have groped with great care," replied the dwarf.

"Then your sense of feeling must be bad," said the other.

"But this globe," said the dwarf, "is ill contrived,

and so irregular in its form as to be quite ridiculous.
The whole together looks like a chaos. Do but
observe these little rivulets; not one of them runs
in a straight line; and these ponds which are neither
round, square, nor oval, nor indeed of any regular
figure; together with these little sharp pebbles
(meaning the mountains) that roughen the whole
surface of the globe, and have torn all the skin from
my feet. Besides, pray take notice of the shape of
the whole, how it flattens at the poles, and turns
round the sun in an awkward oblique manner, so
that the polar circles cannot possibly be cultivated.
Truly, what makes me believe there is no inhabitant
on this sphere is a full persuasion that no sensible
being would live in such a disagreeable place."

"What then?" said Micromegas; "perhaps the be-
ings that inhabit it come not under that denomina-
tion; but, to all appearance, it was not made for
nothing. Everything here seems to you irregular,
because you fetch all your comparisons from Jupiter
or Saturn. Perhaps this is the very reason of the
seeming confusion which you condemn; have I not
told you that in the course of my travels I have al-
ways met with variety?"

The Saturnian replied to all these arguments, and
perhaps the dispute would have known no end, if
Micromegas, in the heat of the contest, had not
luckily broken the string of his diamond necklace,
so that the jewels fell to the ground; they consisted
of pretty small unequal stones, the largest of which

weighed four hundred pounds, and the smallest fifty. The dwarf, in helping to pick them up, perceived, as they approached his eye, that every single diamond was cut in such a manner as to answer the purpose of an excellent microscope. He therefore took up a small one, about one hundred and sixty feet in diameter, and applied it to his eye, while Micromegas chose another of two thousand five hundred feet. Though they were of excellent powers, the observers could perceive nothing by their assistance, so they were altered and adjusted. At length, the inhabitant of Saturn discerned something almost imperceptible moving between two waves in the Baltic. This was no other than a whale, which, in a dextrous manner, he caught with his little finger, and, placing it on the nail of his thumb, showed it to the Sirian, who laughed heartily at the excessive smallness peculiar to the inhabitants of this our globe. The Saturnian, by this time convinced that our world was inhabited, began to imagine we had no other animals than whales; and being a mighty debater, he forthwith set about investigating the origin and motion of this small atom, curious to know whether or not it was furnished with ideas, judgment, and free will. Micromegas was very much perplexed upon this subject. He examined the animal with the most patient attention, and the result of his inquiry was that he could see no reason to believe a soul was lodged in such a body. The two travellers were actually inclined

to think there was no such thing as mind in this our habitation, when, by the help of their microscope, they perceived something as large as a whale floating upon the surface of the sea. It is well known that at this period a flock of philosophers were upon their return from the polar circle, where they had been making observations, for which nobody has hitherto been the wiser. The gazettes record that their vessel ran ashore on the coast of Bothnia and that they with great difficulty saved their lives; but in this world one can never dive to the bottom of things. For my own part, I will ingeniously recount the transaction just as it happened, without any addition of my own; and this is no small effort in a modern historian.

CHAPTER V.

THE TRAVELLERS CAPTURE A VESSEL.

Micromegas stretched out his hand gently toward the place where the object appeared, and advanced two fingers, which he instantly pulled back, for fear of being disappointed; then opening softly and shutting them all at once, he very dextrously seized the ship that contained those gentlemen, and placed it on his nail, avoiding too much pressure, which might have crushed the whole in pieces.

"This," said the Saturnian dwarf, "is a creature very different from the former."

Upon which the Sirian, placing the supposed animal in the hollow of his hand, the passengers and crew, who believed themselves thrown by a hurricane upon some rock, began to put themselves in motion. The sailors having hoisted out some casks of wine, jumped after them into the hand of Micromegas; the mathematicians having secured their quadrants, sectors, and Lapland servants, went overboard at a different place, and made such a bustle in their descent that the Sirian at length felt his fingers tickled by something that seemed to move. An iron bar chanced to penetrate about a foot deep into his forefinger; and from this prick he concluded that something had issued from the little animal he held in his hand; but at first he suspected nothing more, for the microscope, that scarce rendered a whale and a ship visible, had no effect upon an object so imperceptible as man.

I do not intend to shock the vanity of any person whatever; but here I am obliged to request people of importance to consider that, supposing the stature of a man to be about five feet, we mortals make just such a figure upon the earth as an animal the sixty thousandth part of a foot in height would exhibit upon a bowl ten feet in circumference. When you reflect upon a being who could hold this whole earth in the palm of his hand, and is provided with organs proportioned to those we possess, you will easily conceive that there must be a great variety of created substances—and pray, what must

such beings think of those battles by which a conqueror gains a small village, to lose it again in the sequel?

I do not at all doubt but if some captain of grenadiers should chance to read this work, he would add two large feet at least to the caps of his company; but I assure him his labor will be in vain, for, do what he will, he and his soldiers will never be other than infinitely diminutive and inconsiderable.

What wonderful address must have been inherent in our Sirian philosopher that enabled him to perceive these atoms of which we have been speaking. When Leuwenhoek and Hartsoeker observed the first rudiments of which we are formed, they did not make such an astonishing discovery. What pleasure, therefore, was the portion of Micromegas in observing the motion of those little machines, in examining all their pranks, and following them in all their operations! With what joy did he put his microscope into his companion's hand; and with what transport did they both at once exclaim:

"I see them distinctly—don't you see them carrying burdens, lying down and rising up again?"

So saying, their hands shook with eagerness to see and apprehension to lose such uncommon objects. The Saturnian, making a sudden transition from the most cautious distrust to the most excessive credulity, imagined he saw them engaged in their devotions, and cried aloud in astonishment.

Nevertheless, he was deceived by appearances; a case too common, whether we do or do not make use of microscopes.

* * *

CHAPTER VI.

WHAT HAPPENED IN THEIR INTERCOURSE WITH MEN.

Micromegas being a much better observer than the dwarf, perceived distinctly that those atoms spoke; and made the remark to his companion, who was so much ashamed of being mistaken in his first suggestion that he would not believe such a puny species could possibly communicate their ideas, for, though he had the gift of tongues, as well as his companion, he could not hear those particles speak, and, therefore, supposed they had no language.

"Besides, how should such imperceptible beings have the organs of speech? and what in the name of Jove can they say to one another? In order to speak, they must have something like thought, and if they think, they must surely have something equivalent to a soul. Now, to attribute anything like a soul to such an insect species appears a mere absurdity."

"But just now," replied the Sirian, "you believed they were engaged in devotional exercises; and do you think this could be done without thinking, without using some sort of language, or at least

some way of making themselves understood? Or do you suppose it is more difficult to advance an argument than to engage in physical exercise? For my own part, I look upon all faculties as alike mysterious."

"I will no longer venture to believe or deny," answered the dwarf, "in short, I have no opinion at all. Let us endeavor to examine these insects, and we will reason upon them afterward."

"With all my heart," said Micromegas, who, taking out a pair of scissors which he kept for paring his nails, cut off a paring from his thumb nail, of which he immediately formed a large kind of speaking trumpet, like a vast tunnel, and clapped the pipe to his ear; as the circumference of this machine included the ship and all the crew, the most feeble voice was conveyed along the circular fibres of the nail; so that, thanks to his industry, the philosopher could distinctly hear the buzzing of our insects that were below. In a few hours he distinguished articulate sounds, and at last plainly understood the French language. The dwarf heard the same, though with more difficulty.

The astonishment of our travellers increased every instant. They heard a nest of mites talk in a very sensible strain: and that *lusus naturæ* seemed to them inexplicable. You need not doubt but the Sirian and his dwarf glowed with impatience to enter into conversation with such atoms. Micromegas being afraid that his voice, like thunder,

would deafen and confound the mites, without being understood by them, saw the necessity of diminishing the sound; each, therefore, put into his mouth a sort of small tcothpick, the slender end of which reached to the vessel. The Sirian setting the dwarf upon his knees, and the ship and crew upon his nail, held down his head and spoke softly. In fine, having taken these and a great many more precautions, he addressed himself to them in these words:

"O ye invisible insects, whom the hand of the Creator hath deigned to produce in the abyss of infinite littleness! I give praise to His goodness, in that He hath been pleased to disclose unto me those secrets that seemed to be impenetrable."

If ever there was such a thing as astonishment, it seized upon the people who heard this address, and who could not conceive from whence it proceeded. The chaplain of the ship repeated exorcisms, the sailors swore, and the philosophers formed a system; but, notwithstanding all their systems, they could not divine who the person was that spoke to them. Then the dwarf of Saturn, whose voice was softer than that of Micromegas, gave them briefly to understand what species of beings they had to do with. He related the particulars of their voyage from Saturn, made them acquainted with the rank and quality of Monsieur Micromegas, and, after having pitied their smallness, asked if they had always been in that miserable state so near

akin to annihilation; and what their business was
upon that globe which seemed to be the property of
whales. He also desired to know if they were
happy in their situation? if they were inspired with
souls? and put a hundred questions of the like
nature.

A certain mathematician on board, braver than
the rest, and shocked to hear his soul called in
question, planted his quadrant, and having taken
two observations of this interlocutor, said: "You
believe then, Mr. what's your name, that because
you measure from head to foot a thousand
fathoms—"

"A thousand fathoms!" cried the dwarf, "good
heavens! How should he know the height of my
stature? A thousand fathoms! My very dimen-
sions to a hair. What, measured by a mite! This
atom, forsooth, is a geometrician, and knows
exactly how tall I am; while I, who can scarce per-
ceive him through a microscope, am utterly igno-
rant of his extent!"

"Yes, I have taken your measure," answered
the philosopher, "and I will now do the same by
your tall companion."

The proposal was embraced; his excellency re-
clined upon his side, for, had he stood upright, his
head would have reached too far above the clouds.
Our mathematicians planted a tall tree near him,
and then, by a series of triangles joined together,
they discovered that the object of their observation

was a strapping youth, exactly one hundred and
twenty thousand royal feet in length. In conse-
quence of this calculation, Micromegas uttered
these words:

"I am now more than ever convinced that we
ought to judge of nothing by its external magni-
tude. O God! who hast bestowed understanding
upon such seemingly contemptible substances,
Thou canst with equal ease produce that which is
infinitely small, as that which is incredibly great;
and if it be possible that among thy works there
are beings still more diminutive than these, they
may, nevertheless, be endued with understanding
superior to the intelligence of those stupendous
animals I have seen in heaven, a single foot of whom
is larger than this whole globe on which I have
alighted."

One of the philosophers assured him that there
were intelligent beings much smaller than men, and
recounted not only Virgil's whole fable of the bees,
but also described all that Swammerdam hath dis-
covered and Reaumur dissected. In a word, he
informed him that there are animals which bear the
same proportion to bees that bees bear to man, the
same as the Sirian himself compared to those vast
beings whom he had mentioned, and as those huge
animals are to other substances, before whom they
would appear like so many particles of dust. Here
the conversation became very interesting, and Mic-
romegas proceeded in these words:

"O ye intelligent atoms, in whom the Supreme Being hath been pleased to manifest his omniscience and power, without all doubt your joys on this earth must be pure and exquisite; for, being unincumbered with matter, and, to all appearance, little else than soul, you must spend your lives in the delights of pleasure and reflection, which are the true enjoyments of a perfect spirit. True happiness I have nowhere found; but certainly here it dwells."

At this harangue all the philosophers shook their heads, and one among them, more candid than his brethren, frankly owned that, excepting a very small number of inhabitants who were very little esteemed by their fellows, all the rest were a parcel of knaves, fools, and miserable wretches.

"We have matter enough," said he, "to do abundance of mischief, if mischief comes from matter; and too much understanding, if evil flows from understanding. You must know, for example, that at this very moment, while I am speaking, there are one hundred thousand animals of our own species, covered with hats, slaying an equal number of their fellow-creatures who wear turbans; at least they are either slaying or being slain; and this hath usually been the case all over the earth from time immemorial."

The Sirian, shuddering at this information, begged to know the cause of those horrible quarrels among such a puny race, and was given to under-

stand that the subject of the dispute was a pitiful mole-hill (called Palestine), no larger than his heel. Not that any one of those millions' who cut one another's throats pretends to have the least claim to the smallest particle of that clod. The question is, whether it shall belong to a certain person who is known by the name of Sultan, or to another whom (for what reason I know not) they dignify with the appellation of Pope. Neither the one nor the other has seen or ever will see the pitiful corner in question; and probably none of these wretches, who so madly destroy each other, ever beheld the ruler on whose account they are so mercilessly sacrificed!

"Ah, miscreants!" cried the indignant Sirian, "such excess of desperate rage is beyond conception. I have a good mind to take two or three steps, and trample the whole nest of such ridiculous assassins under my feet."

"Don't give yourself the trouble," replied the philosopher; "they are industrious enough in procuring their own destruction. At the end of ten years the hundredth part of those wretches will not survive; for you must know that, though they should not draw a sword in the cause they have espoused, famine, fatigue, and intemperance would sweep almost all of them from the face of the earth. Besides, the punishment should not be inflicted upon them, but upon those sedentary and slothful barbarians, who, from their palaces, give orders for

murdering a million of men and then solemnly
thank God for their success."

Our traveller was moved with compassion for
the entire human race, in which he discovered such
astonishing contrasts. "Since you are of the small
number of the wise," said he, "and in all likelihood
do not engage yourselves in the trade of murder
for hire, be so good as to tell me your occupation."

"We anatomize flies," replied the philosopher,
"we measure lines, we make calculations, we agree
upon two or three points which we understand, and
dispute upon two or three thousand that are beyond
our comprehension."

"How far," said the Sirian, "do you reckon the
distance between the great star of the constellation
Gemini and that called Canicula?"

To this question all of them answered with one
voice: "Thirty-two degrees and a half."

"And what is the distance from thence to the
moon?"

"Sixty semi-diameters of the earth."

He then thought to puzzle them by asking the
weight of the air; but they answered distinctly that
common air is about nine hundred times specifically
lighter than an equal column of the lightest water,
and nineteen hundred times lighter than current
gold. The little dwarf of Saturn, astonished at their
answers, was now tempted to believe those people
sorcerers who, but a quarter of an hour before, he
would not allow were inspired with souls.

"Well," said Micromegas, "since you know so well what is without you, doubtless you are still more perfectly acquainted with that which is within. Tell me what is the soul, and how do your ideas originate?"

Here the philosophers spoke altogether as before; but each was of a different opinion. The eldest quoted Aristotle, another pronounced the name of Descartes, a third mentioned Malebranche, a fourth Leibnitz, and a fifth Locke. An old peripatetic, lifting up his voice, exclaimed with an air of confidence: "The soul is perfection and reason, having power to be such as it is, as Aristotle expressly declares, page 633, of the Louvre edition:

"Ἐντελεχεῖά τις ἐστί, καὶ λόγος τοῦ δύναμιν ἔχοντος τοιοῦδι εἶταἶ."

"I am not very well versed in Greek," said the giant.

"Nor I, either," replied the philosophical mite.

"Why, then, do you quote that same Aristotle in Greek," resumed the Sirian.

"Because," answered the other, "it is but reasonable we should quote what we do not comprehend in a language we do not understand."

Here the Cartesian interposing: "The soul," said he, "is a pure spirit or intelligence, which hath received before birth all the metaphysical ideas; but after that event it is obliged to go to school and learn anew the knowledge which it hath lost."

"So it is necessary," replied the animal of eight

leagues, "that thy soul should be learned before birth, in order to be so ignorant when thou hast got a beard upon thy chin. But what dost thou understand by spirit?"

"I have no idea of it," said the philosopher; "indeed, it is supposed to be immaterial."

"At least, thou knowest what matter is?" resumed the Sirian.

"Perfectly well," answered the other. "For example: that stone is gray, is of a certain figure, has three dimensions, specific weight, and divisibility."

"I want to know," said the giant, "what that object is, which, according to thy observation, hath a gray color, weight and divisibility. Thou seest a few qualities, but dost thou know the nature of the thing itself?"

"Not I, truly," answered the Cartesian.

Upon which the Sirian admitted that he also was ignorant in regard to this subject. Then addressing himself to another sage, who stood upon his thumb, he asked: "What is the soul? and what are its functions?"

"Nothing at all," replied this disciple of Malebranche; "God hath made everything for my convenience. In Him I see everything, by Him I act; He is the universal agent, and I never meddle in His work."

"That is being a nonentity indeed," said the Sirian sage; and then, turning to a follower of Leib-

nitz, he exclaimed: "Hark ye, friend, what is thy opinion of the soul?"

"In my opinion," answered this metaphysician, "the soul is the hand that points at the hour, while my body does the office of the clock; or, if you please, the soul is the clock, and the body is the pointer; or again, my soul is the mirror of the universe, and my body the frame. All this is clear and uncontrovertible."

A little partisan of Locke, who chanced to be present, being asked his opinion on the same subject, said: "I do not know by what power I think; but well I know that I should never have thought without the assistance of my senses. That there are immaterial and intelligent substances I do not at all doubt; but that it is impossible for God to communicate the faculty of thinking to matter, I doubt very much. I revere the Eternal Power, to which it would ill become me to prescribe bounds. I affirm nothing, and am contented to believe that many more things are possible than are usually thought so."

The Sirian smiled at this declaration, and did not look upon the author as the least sagacious of the company; and as for the dwarf of Saturn, he would have embraced this adherent of Locke, had it not been for the extreme disproportion in their respective sizes. But unluckily there was another animalcule in a square cap, who, taking the word from all his philosophical brethren, affirmed that he knew the

whole secret, which was contained in the abridgment of St. Thomas. He surveyed the two celestial strangers from top to toe, and maintained to their faces that their persons, their fashions, their suns, and their stars were created solely for the use of man. At this wild assertion our two travellers were seized with a fit of that uncontrollable laughter, which (according to Homer) is the portion of the immortal gods; their bellies quivered, their shoulders rose and fell, and, during these convulsions, the vessel fell from the Sirian's nail into the Saturnian's pocket, where these worthy people searched for it a long time with great diligence. At length, having found the ship and set everything to rights again, the Sirian resumed the discourse with those diminutive mites, and promised to compose for them a choice book of philosophy which would demonstrate the very essence of things. Accordingly, before his departure, he made them a present of the book, which was brought to the Academy of Sciences at Paris, but when the old secretary came to open it he saw nothing but blank paper, upon which—

"Ay, ay," said he, " this is just what I suspected."

THE HISTORY OF THE TRAVELS OF SCARMENTADO.

I was born in Candia, in the year 1600. My father was governor of the city; and I remember that a poet of middling parts, and of a most unmusical ear, whose name was Iro, composed some verses in my praise, in which he made me to descend from Minos in a direct line; but my father being afterwards disgraced, he wrote some other verses, in which he derived my pedigree from no nobler an origin than the amours of Pasiphaë and her gallant. This Iro was a most mischievous rogue, and one of the most troublesome fellows in the island.

My father sent me at fifteen years of age to prosecute my studies at Rome. There I arrived in full hopes of learning all kinds of truth, for I had hitherto been taught quite the reverse, according to the custom of this lower world from China to the Alps. Monsignor Profondo, to whom I was recommended, was a man of a very singular character, and one of the most terrible scholars in the world. He was for teaching me the categories of Aristotle; and was just on the point of placing me in the category of his minions; a fate which I narrowly escaped. I saw processions, exorcisms, and some robberies.

It was commonly said, but without any foundation, that la Signora Olympia, a lady of great prudence, had deceived many lovers, she being both inconstant and mercenary. I was then of an age to relish such comical anecdotes.

A young lady of great sweetness of temper, called la Signora Fatelo, thought proper to fall in love with me. She was courted by the reverend father Piognardini and by the reverend father Aconiti,* young monks of an order now extinct; and she reconciled the two rivals by declaring her preference for me; but at the same time I ran the risk of being excommunicated and poisoned. I left Rome highly pleased with the architecture of St. Peter's.

I travelled to France. It was during the reign of Louis the Just. The first question put to me was, whether I chose to breakfast on a slice of the Marshal d'Ancre,† whose flesh the people had roasted and distributed with great liberality to such as chose to taste it.

This kingdom was continually involved in civil wars; sometimes for a place at court, sometimes for

*Alluding to the infamous practice of poisoning and assassination at that time prevalent in Rome.—*Trans.*

† This was the famous Concini, who was murdered on the drawbridge of the Louvre, by the intrigues of De Luines, not without the knowledge of the king, Louis XIII. His body, which had been secretly interred in the church of St. Germain l'Auxerrois, was next day dug up by the populace, who dragged it through the streets, then burned the flesh, and threw the bones into the river. The marshal's greatest crime was his being a foreigner.—*Tr.*

two pages of theological controversy. This fire, which at one time lay concealed under the ashes, and at another burst forth with great violence, had desolated these beautiful provinces for upwards of sixty years. The pretext was, defending the liberties of the Gallican church. "Alas!" said I, "these people are nevertheless born with a gentle disposition. What can have drawn them so far from their natural character? They joke and keep holy days.* Happy the time when they shall do nothing but joke!"

I went over to England, where the same disputes occasioned the same barbarities. Some pious Catholics had resolved, for the good of the church, to blow up into the air with gunpowder the king, the royal family, and the whole parliament, and thus to deliver England from all these heretics at once. They showed me the place where Queen Mary of blessed memory, the daughter of Henry VIII., had caused more than five hundred of her subjects to be burnt. An Irish priest assured me that it was a very good action; first, because those who were burnt were Englishmen, and secondly, because they did not make use of holy water, nor believe in St. Patrick. He was greatly surprised that Queen Mary was not yet canonized, but he hoped she would receive that honor as soon as the cardinal should be a little more at leisure.

* Referring to the massacre of Protestants, on the eve of St. Bartholomew.—*Tr.*

From thence I went to Holland, where I hoped to find more tranquillity among a people of a more cold and phlegmatic temperament. Just as I arrived at The Hague the people were cutting off the head of a venerable old man. It was the bald head of the prime minister, Barneveldt—a man who deserved better treatment from the republic. Touched with pity at this affecting scene, I asked what was his crime, and whether he had betrayed the state.

"He has done much worse," replied a preacher in a black cloak; "he believed that men may be saved by good works as well as by faith. You must perceive," adds he, "that if such opinions were to gain ground, a republic could not subsist, and that there must be severe laws to suppress such scandalous and horrid blasphemies."

A profound politician said to me with a sigh: "Alas! sir, this happy time will not last long; it is only by chance that the people are so zealous. They are naturally inclined to the abominable doctrine of toleration, and they will certainly at last grant it." This reflection set him a-groaning.

For my own part, in expectation of that fatal period when moderation and indulgence should take place, I instantly quitted a country where severity was not softened by any lenitive, and embarked for Spain.

The court was then at Seville. The galleons had just arrived, and everything breathed plenty and

gladness, in the most beautiful season of the year. I observed, at the end of an alley of orange and citron trees, a kind of large ring, surrounded with steps covered with rich and costly cloth. The king, the queen, the *infantes,* and the *infantas* were seated under a superb canopy. Opposite to the royal family was another throne, raised higher than that on which his majesty sat. I said to a fellow-traveller: "Unless this throne be reserved for God, I don't see what purpose it can serve."

This unguarded expression was overheard by a grave Spaniard, and cost me dear. Meanwhile, I imagined we were going to a carousal, or a match of bull-baiting, when the grand inquisitor appeared on that elevated throne, from whence he blessed the king and the people.

Then came an army of monks, who filed off in pairs, white, black, gray, shod, unshod, bearded, beardless, with pointed cowls, and without cowls. Next followed the hangman, and last of all were seen, in the midst of the guards and grandees, about forty persons clad in sackcloth, on which were painted the figures of flames and devils. Some of these were Jews, who could not be prevailed upon to renounce Moses entirely; others were Christians who had married women with whom they had stood sponsors to a child; who had not adored our Lady of Atocha; or who had refused to part with their ready money in favor of the Hieronymite brothers. Some pretty prayers were sung with much devotion

and then the criminals were burnt at a slow fire—
a ceremony with which the royal family seemed to
be greatly edified.

As I was going to bed in the evening, two mem-
bers of the Inquisition came to my lodging with the
Santa Hermandad. They embraced me with great
tenderness, and conducted me in solemn silence to
a well-aired prison, furnished with a bed of mat,
and a beautiful crucifix. There I remained for six
weeks, at the end of which time the reverend father,
the inquisitor, sent for me. He pressed me in his
arms for some time with the most paternal affec-
tion, and told me that he was sorry to hear that I
had been so ill lodged; but that all the apartments
of the house were full, and hoped I should be better
accommodated the next time. He then asked me
with great cordiality if I knew for what reason I
was imprisoned.

I told the reverend father that it was evidently
for my sins.

"Very well," said he, "my dear child; but for
what particular sin? Speak freely."

I racked my brain with conjectures, but could
not possibly guess. He then charitably dismissed
me. At last I remembered my unguarded expres-
sion. I escaped with a little bodily correction, and
a fine of thirty thousand reals. I was led to make
my obeisance to the grand inquisitor, who was a man
of great politeness. He asked me how I liked his
little feast. I told him it was a most delicious one,

and then went to press my companions to quit the country, beautiful as it was.

They had, during my imprisonment, found time to inform themselves of all the great things which the Spaniards had done for the interest of religion. They had read the memoirs of the famous bishop of Chiapa, by which it appears that they had massacred, or burnt, or drowned, about ten millions of infidels in America, in order to convert them. I believe the accounts of the bishop are a little exaggerated; but suppose we reduce the number of victims to five millions, it will still be a most glorious achievement.

The impulse for travelling still possessed me. I had proposed to finish the tour of Europe with Turkey, and thither we now directed our course. I made a firm resolution not to give my opinion of any public feasts I might see in the future. "These Turks," said I to my companions, "are a set of miscreants that have not been baptized, and therefore will be more cruel than the reverend fathers, the inquisitors. Let us observe a profound silence while we are among the Mahometans." When we arrived there I was greatly surprised to see more Christian churches in Turkey than in Candia. I saw also numerous troops of monks, who were allowed to pray to the Virgin Mary with great freedom, and to curse Mahomet—some in Greek, some in Latin, and others in Armenian. "What good-natured people are these Turks," cried I.

The Greek Christians and the Latin Christians in Constantinople were mortal enemies. These sectarians persecuted each other in much the same manner as dogs fight in the streets, till their masters part them with a cudgel.

The grand vizier was at that time the protector of the Greeks. The Greek patriarch accused me of having supped with the Latin patriarch, and I was condemned in full divan to receive a hundred blows on the soles of my feet, redeemable for five hundred sequins. The next day the grand vizier was strangled. The day following his successor, who was for the Latin party, and who was not strangled till a month after, condemned me to suffer the same punishment for having supped with the Greek patriarch. Thus was I reduced to the sad necessity of absenting myself entirely from the Greek and Latin churches.

In order to console myself for this loss, I frequently visited a very handsome Circassian. She was the most entertaining lady I ever knew in a private conversation, and the most devout at the mosque. One evening she received me with tenderness and sweetly cried, "Allah, Illah, Allah!"

These are the sacramental words of the Turks. I imagined they were the expressions of love, and therefore cried in my turn, and with a very tender accent, "Allah, Illah, Allah!"

"Ah!" said she, "God be praised, thou art then a Turk?"

I told her that I was blessing God for having given me so much enjoyment, and that I thought myself extremely happy.

In the morning the imaum came to enroll me among the circumcised, and as I made some objection to the initiation, the cadi of that district— a man of great loyalty—proposed to have me empaled. I preserved my freedom by paying a thousand sequins, and then fled directly into Persia, resolved for the future never to hear Greek or Latin mass, nor to cry "Allah, Illah, Allah!" in a love encounter.

On my arrival at Ispahan the people asked me whether I was for white or black mutton? I told them that it was a matter of indifference to me, provided it was tender. It must be observed that the Persian empire was at that time split into two factions, that of the white mutton and that of the black. The two parties imagined that I had made a jest of them both, so that I found myself engaged in a very troublesome affair at the gates of the city, and it cost me a great number of sequins to get rid of the white and the black mutton.

I proceeded as far as China, in company with an interpreter, who assured me that this country was the seat of gayety and freedom. The Tartars had made themselves masters of it, after having destroyed everything with fire and sword.

The reverend fathers, the Jesuits, on the one hand, and the reverend fathers, the Dominicans,

on the other, alleged that they had gained many
souls to God in that country, without any one
knowing aught of the matter. Never were seen
such zealous converters. They alternately perse-
cuted one another; they transmitted to Rome
whole volumes of slander, and treated each other
as infidels and prevaricators for the sake of one
soul. But the most violent dispute between them
was with regard to the manner of making a bow.
The Jesuits would have the Chinese to salute their
parents after the fashion of China, and the Domin-
icans would have them to do it after the fashion of
Rome.

I happened unluckily to be taken by the Jesuits
for a Dominican. They represented me to his Tar-
tarian majesty as a spy of the pope. The supreme
council charged a prime mandarin, who ordered a
sergeant, who commanded four shires of the coun-
try, to seize me and bind me with great ceremony.
In this manner I was conducted before his majesty,
after having made about a hundred and forty gen-
uflections. He asked me if I was a spy of the
pope's, and if it was true that that prince was to
come in person to dethrone him. I told him that
the pope was a priest of seventy years of age; that
he lived at the distance of four thousand leagues
from his sacred Tartaro-Chinese majesty; that he
had about two thousand soldiers, who mounted
guard with umbrellas; that he never dethroned any-

body; and that his majesty might sleep in perfect
security.

Of all the adventures of my life this was the
least fatal. I was sent to Macao, and there I took
shipping for Europe.

My ship required to be refitted on the coast of
Golconda. I embraced this opportunity to visit
the court of the great Aurung-Zeb, of whom such
wonderful things have been told, and which was
then in Delphi. I had the pleasure to see him on
the day of that pompous ceremony in which he
receives the celestial present sent him by the Sherif
of Mecca. This was the besom with which they had
swept the holy house, the Kaaba, and the Beth
Alla. It is a symbol that sweeps away all the pol-
lutions of the soul.

Aurung-Zeb seemed to have no need of it. He
was the most pious man in all Indostan. It is true,
he had cut the throat of one of his brothers, and
poisoned his father. Twenty rayas, and as many
omras, had been put to death; but that was a
trifle. Nothing was talked of but his devotion.
No king was thought comparable to him, except
his sacred majesty, Muley Ismael, the most serene
emperor of Morocco, who always cut off some
heads every Friday after prayers.

I spoke not a word. My travels had taught me
wisdom. I was sensible that it did not belong to
me to decide between these august sovereigns. A

young Frenchman, a fellow lodger of mine, was, however, greatly wanting in respect to both the emperor of the Indies, and to that of Morocco. He happened to say, very imprudently, that there were sovereigns in Europe who governed their dominions with great equity, and even went to church without killing their fathers or brothers, or cutting off the heads of their subjects.

This indiscreet discourse of my young friend the interpreter at once translated. Instructed by former experience, I instantly caused my camels to be saddled, and set out with my Frenchman. I was afterwards informed that the officers of the great Aurung-Zeb came that very night to seize me, but finding only the interpreter, they publicly executed him, and the courtiers all claimed, very justly, that his punishment was well deserved.

I had now only Africa to visit in order to enjoy all the pleasures of our continent, and thither I went to complete my voyage. The ship in which I embarked was taken by the negro corsairs. The master of the vessel complained loudly, and asked why they thus violated the laws of nations. The captain of the negroes thus replied:

"You have a long nose, and we have a short one. Your hair is straight, and ours is curled; your skin is ash-colored, and ours is of the color of ebon; and therefore we ought, by the sacred laws of nature, to be always at enmity. You buy us in the public markets on the coast of Guinea like beasts of

burden, to make us labor in I don't know what kind of drudgery, equally hard and ridiculous. With the whip held over our heads, you make us dig in mines for a kind of yellow earth, which in itself is good for nothing, and is not so valuable as an Egyptian onion. In like manner, wherever we meet you, and are superior to you in strength, we make you slaves, and oblige you to cultivate our fields, or in case of refusal we cut off your nose and ears."

To such a learned discourse it was impossible to make any answer. I submitted to labor in the garden of an old negress, in order to save my nose and ears. After continuing in slavery for a whole year I was at length happily ransomed.

As I had now seen all that was rare, good, or beautiful on earth, I resolved for the future to see nothing but my own home. I took a wife, and soon suspected that she deceived me; but notwithstanding this doubt, I still found that of all conditions of life this was much the happiest.

THE PRINCESS OF BABYLON.

CHAPTER I.

ROYAL CONTEST FOR THE HAND OF FORMOSANTA.

The aged Belus, king of Babylon, thought himself the first man upon earth; for all his courtiers told him so, and his historians proved it. We know that his palace and his park, situated a few parasangs from Babylon, extended between the Euphrates and the Tigris, which washed those enchanted banks. His vast house, three thousand feet in front, almost reached the clouds. The platform was surrounded with a balustrade of white marble, fifty feet high, which supported colossal statues of all the kings and great men of the empire. This platform, composed of two rows of bricks, covered with a thick surface of lead from one extremity to the other, bore twelve feet of earth; and upon the earth were raised groves of olive, orange, citron, palm, cocoa, and cinnamon trees, and stock gillyflowers, which formed alleys that the rays of the sun could not penetrate.

The waters of the Euphrates running, by the assistance of pumps, in a hundred canals, formed cascades of six thousand feet in length in the park, and a hundred thousand *jets d'eau,* whose height was

scarce perceptible. They afterwards flowed into the
Euphrates, whence they came. The gardens of
Semiramis, which astonished Asia several ages after,
were only a feeble imitation of these ancient prod-
igies; for in the time of Semiramis, everything be-
gan to degenerate among men and women.

But what was more admirable in Babylon, and
eclipsed everything else, was the only daughter of
the king, named Formosanta. It was from her pic-
tures and statues that, in succeeding times, Praxiteles
sculptured his Aphrodite, and the Venus of Medicis.
Heavens! what a difference between the original
and the copies! So that King Belus was prouder of
his daughter than of his kingdom. She was eighteen
years old. It was necessary she should have a hus-
band worthy of her; but where was he to be found?
An ancient oracle had ordained that Formosanta
could not belong to any but him who could bend the
bow of Nimrod.

This Nimrod, "a mighty hunter before the Lord,"
(Gen. x: 9) had left a bow seventeen Babylonian
feet in length, made of ebony, harder than the iron
of Mount Caucasus, which is wrought in the forges
of Derbent; and no mortal since Nimrod could bend
this astonishing bow.

It was again said "that the arm which should bend
this bow would kill the most terrible and ferocious
lion that should be let loose in the Circus of Babylon."
This was not all. The bender of the bow and the
conqueror of the lion should overthrow all his rivals;

but he was above all things to be very sagacious, the most magnificent and most virtuous of men, and possess the greatest curiosity in the whole universe.

Three kings appeared, who were bold enough to claim Formosanta—Pharaoh of Egypt, the Shah of India, and the great Khan of the Scythians. Belus appointed the day and place of combat, which was to be at the extremity of his park, in the vast expanse surrounded by the joint waters of the Euphrates and the Tigris. Round the lists a marble·amphitheatre was erected, which might contain five hundred thousand spectators. Opposite the amphitheatre was placed the king's throne. He was to appear with Formosanta, accompanied by the whole court; and on the right and left between the throne and the amphitheatre, there were other thrones and seats for the three kings, and for all the other sovereigns who were desirous to be present at this august ceremony.

The king of Egypt arrived the first, mounted upon the bull Apis, and holding in his hand the cithern of Isis. He was followed by two thousand priests, clad in linen vestments whiter than snow, two thousand eunuchs, two thousand magicians, and two thousand warriors.

The king of India came soon after in a car drawn by twelve elephants. He had a train still more numerous and more brilliant than Pharaoh of Egypt.

The last who appeared was the king of the Scythians. He had none with him but chosen warriors, armed with bows and arrows. He was mounted

upon a superb tiger, which he had tamed, and which was as tall as any of the finest Persian horses. The majestic and important mien of this king effaced the appearance of his rivals; his naked arms, as nervous as they were white, seemed already to bend the bow of Nimrod.

These three lovers immediately prostrated themselves before Belus and Formosanta. The king of Egypt presented the princess with two of the finest crocodiles of the Nile, two sea horses, two zebras, two Egyptian rats, and two mummies, with the books of the great Hermes, which he judged to be the scarcest things upon earth.

The king of India offered her a hundred elephants, each bearing a wooden gilt tower, and laid at her feet the *vedam,* written by the hand of Xaca himself.

The king of the Scythians, who could neither write nor read, presented a hundred warlike horses with black fox-skin housings.

The princess appeared with a downcast look before her lovers, and reclined herself with a grace that was at once modest and noble.

Belus ordered the kings to be conducted to the thrones that were prepared for them. "Would I had three daughters," said he to them, "I should make six people this day happy!" He then made the competitors cast lots which should try Nimrod's bow first. Their names inscribed were put into a golden casque. That of the Egyptian king came out first, then the name of the king of India appeared. The king of

Scythia, viewing the bow and his rivals, did not complain at being the third.

While these brilliant trials were preparing, twenty thousand pages and twenty thousand youthful maidens distributed, without any disorder, refreshments to the spectators between the rows of seats. Every one acknowledged that the gods had instituted kings for no other cause than every day to give festivals, upon condition they should be diversified—that life is too short for any other purpose; that lawsuits, intrigues, wars, the altercations of theologists, which consume human life, are horrible and absurd; that man is born only for happiness; that he would not passionately and incessantly pursue pleasure were he not designed for it; that the essence of human nature is to enjoy ourselves, and all the rest is folly. This excellent moral was never controverted but by facts.

While preparations were being made for determining the fate of Formosanta, a young stranger, mounted upon a unicorn, accompanied by his valet, mounted on a like animal, and bearing upon his hand a large bird, appeared at the barrier. The guards were surprised to observe in this equipage a figure that had an air of divinity. He had, as has been since related, the face of Adonis upon the body of Hercules; it was majesty accompanied by the graces. His black eyebrows and flowing fair tresses, wore a mixture of beauty unknown at Babylon, and charmed all observers. The whole amphitheatre rose up, the

better to view the stranger. All the ladies of the
court viewed him with looks of astonishment. For-
mosanta herself, who had hitherto kept her eyes fixed
upon the ground, raised them and blushed. The
three kings turned pale. The spectators, in compar-
ing Formosanta with the stranger, cried out, "There
is no other in the world but this young man who can
be so handsome as the princess."

The ushers, struck with astonishment, asked him
if he was a king? The stranger replied that he had
not that honor, but that he had come from a distant
country, excited by curiosity, to see if there were
any king worthy of Formosanta. He was introduced
into the first row of the amphitheatre, with his valet,
his two unicorns, and his bird. He saluted, with
great respect, Belus, his daughter, the three kings,
and all the assembly. He then took his seat, not
without blushing. His two unicorns lay down at his
feet; his bird perched upon his shoulder; and his
valet, who carried a little bag, placed himself by his
side.

The trials began. The bow of Nimrod was taken
out of its golden case. The first master of ceremonies,
followed by fifty pages, and preceded by twenty
trumpets, presented it to the king of Egypt, who
made his priest bless it; and supporting it upon the
head of the bull Apis, he did not question his gaining
this first victory. He dismounted, and came into
the middle of the circus. He tried, exerted all his
strength, and made such ridiculous contortions that

the whole amphitheatre re-echoed with laughter, and Formosanta herself could not help smiling.

His high almoner approached him:

"Let your majesty give up this idle honor, which depends entirely upon the nerves and muscles. You will triumph in everything else. You will conquer the lion, as you are possessed of the favor of Osiris. The princess of Babylon is to belong to the prince who is most sagacious, and you have solved enigmas. She is to wed the most virtuous; you are such, as you have been educated by the priests of Egypt. The most generous is to marry her, and you have presented her with two of the handsomest crocodiles, and two of the finest rats in all the Delta. You are possessed of the bull Apis, and the books of Hermes, which are the scarcest things in the universe. No one can hope to dispute Formosanta with you."

"You are in the right," said the king of Egypt, and resumed his throne.

The bow was then put in the hands of the king of India. It blistered his hands for a fortnight; but he consoled himself in presuming that the Scythian king would not be more fortunate than himself.

The Scythian handled the bow in his turn. He united skill with strength. The bow seemed to have some elasticity in his hands. He bent it a little, but he could not bring it near a curve. The spectators, who had been prejudiced in his favor by his agreeable aspect, lamented his ill success, and concluded that the beautiful princess would never be married.

The unknown youth leaped into the arena and, addressing himself to the king of Scythia, said:

"Your majesty need not be surprised at not having entirely succeeded. These ebony bows are made in my country. There is a peculiar method in using them. Your merit is greater in having bent it than if I were to curve it."

He then took an arrow, and placing it upon the string, bent the bow of Nimrod, and shot the arrow beyond the gates. A million hands at once applauded the prodigy. Babylon re-echoed with acclamations; and all the ladies agreed it was fortunate for so handsome a youth to be so strong.

He took out of his pocket a small ivory tablet, wrote upon it with a golden pencil, fixed the tablet to the bow, and presented it to the princess with such a grace as charmed every spectator. He then modestly returned to his place between his bird and his valet. All Babylon was in astonishment; the three kings were confounded; while the stranger did not seem to pay the least attention to what had happened.

Formosanta was still more surprised to read upon the ivory tablet, tied to the bow, these lines, written in the best Chaldæan:

L'arc de Nemrod est celui de la guerre;
L'arc de l'amour est celui du bonheur;
Vous le portez. Par vous ce Dieu vainqueur
Est devenu le maître de la terre.
Trois Rois puissants, trois rivaux aujourd'hui,
Osent prétendre à l'honneur de vous plaire.
Je ne sais pas qui votre cœur préfère,
Mais l'univers sera jaloux de lui.

[The bow of Nimrod is that of war;
 The bow of love is that of happiness—
 Which you possess. Through you this conquering God
 Has become master of the earth.
 Three powerful kings, three rivals now,
 Dare aspire to the honor of pleasing you.
 I know not whom your heart may prefer,
 But the universe will be jealous of him.]

This little madrigal did not displease the princess; but it was criticised by some of the lords of the ancient court, who said that, in former times, Belus would have been compared to the sun, and Formosanta to the moon; his neck to a tower, and her breast to a bushel of wheat. They said the stranger had no sort of imagination, and that he had lost sight of the rules of true poetry, but all the ladies thought the verses very gallant. They were astonished that a man who handled a bow so well should have so much wit. The lady of honor to the princess said to her:

"Madam, what great talents are here entirely lost? What benefit will this young man derive from his wit, and his skill with Nimrod's bow?"

"Being admired!" said Formosanta.

"Ah!" said the lady, "one more madrigal, and he might well be beloved."

The king of Babylon, having consulted his sages, declared that though none of these kings could bend the bow of Nimrod, yet, nevertheless, his daughter was to be married, and that she should belong to him who could conquer the great lion, which was purposely kept in training in his great menagerie.

The king of Egypt, upon whose education all the

wisdom of Egypt had been exhausted, judged it very ridiculous to expose a king to the ferocity of wild beasts in order to be married. He acknowledged that he considered the possession of Formosanta of inestimable value, but he believed that if the lion should strangle him, he could never wed this fair Babylonian. The king of India held similar views to the king of Egypt. They both concluded that the king of Babylon was laughing at them, and that they should send for armies to punish him—that they had many subjects who would think themselves highly honored to die in the service of their masters, without it costing them a single hair of their sacred heads—that they could easily dethrone the king of Babylon, and then they would draw lots for the fair Formosanta.

This agreement being made, the two kings sent each an express into his respective country, with orders to assemble three hundred thousand men to carry off Formosanta.

However, the king of Scythia descended alone into the arena, scimitar in hand. He was not distractedly enamored with Formosanta's charms. Glory till then had been his only passion, and it had led him to Babylon. He was willing to show that if the kings of India and Egypt were so prudent as not to tilt with lions, he was courageous enough not to decline the combat, and he would repair the honor of diadems. His uncommon valor would not even allow him to avail himself of the assistance of his

tiger. He advanced singly, slightly armed with a shell casque ornamented with gold, and shaded with three horses' tails as white as snow.

One of the most enormous and ferocious lions that fed upon the Antilibanian mountains was let loose upon him. His tremendous paws appeared capable of tearing the three kings to pieces at once, and his gullet to devour them. The two proud champions fled with the utmost precipitancy and in the most rapid manner to each other. The courageous Scythian plunged his sword into the lion's mouth; but the point meeting with one of those thick teeth that nothing can penetrate, was broken; and the monster of the woods, more furious from his wound, had already impressed his fearful claws into the monarch's sides.

The unknown youth, touched with the peril of so brave a prince, leaped into the arena swift as lightning, and cut off the lion's head with as much dexterity as we have lately seen, in our carousals, youthful knights knock off the heads of black images.

Then drawing out a small box, he presented it to the Scythian king, saying to him:

"Your majesty will here find the genuine dittany, which grows in my country. Your glorious wounds will be healed in a moment. Accident alone prevented your triumph over the lion. Your valor is not the less to be admired."

The Scythian king, animated more with gratitude than jealousy, thanked his benefactor, and, after hav-

ing tenderly embraced him, returned to his seat to apply the dittany to his wounds.

The stranger gave the lion's head to his valet, who, having washed it at the great fountain which was beneath the amphitheatre, and drained all the blood, took an iron instrument out of his little bag, with which having drawn the lion's forty teeth, he supplied their place with forty diamonds of equal size.

His master, with his usual modesty, returned to his place; he gave the lion's head to his bird. "Beauteous bird," said he, "carry this small homage, and lay it at the feet of Formosanta."

The bird winged its way with the dreadful triumph in one of its talons, and presented it to the princess, bending with humility his neck, and crouching before her. The sparkling diamonds dazzled the eyes of every beholder. Such magnificence was unknown even in superb Babylon. The emerald, the topaz, the sapphire, and the pyrope, were as yet considered as the most precious ornaments. Belus and the whole court were struck with admiration. The bird which presented this present surprised them still more. It was of the size of an eagle, but its eyes were as soft and tender as those of the eagle are fierce and threatening. Its bill was rose color, and seemed somewhat to resemble Formosanta's handsome mouth. Its neck represented all the colors of Iris, but was still more striking and brilliant. Gold, in a thousand shades, glittered upon its plum-

age. Its feet resembled a mixture of silver and purple. And the tails of those beautiful birds, which have since drawn Juno's car, did not equal the splendor of this incomparable bird.

The attention, curiosity, astonishment, and ecstasy of the whole court were divided between the jewels and the bird. It had perched upon the balustrade between Belus and his daughter Formosanta. She petted it, caressed it, and kissed it. It seemed to receive her attentions with a mixture of pleasure and respect. When the princess gave the bird a kiss, it returned the embrace, and then looked upon her with languishing eyes. She gave it biscuits and pistachios, which it received in its purple-silvered claw and carried to its bill with inexpressible grace.

Belus, who had attentively considered the diamonds, concluded that scarce any one of his provinces could repay so valuable a present. He ordered that more magnificent gifts should be prepared for the stranger than those destined for the three monarchs. "This young man," said he, "is doubtless son to the emperor of China; or of that part of the world called Europe, which I have heard spoken of; or of Africa, which is said to be in the vicinity of the kingdom of Egypt."

He immediately sent his first equerry to compliment the stranger, and ask him whether he was himself the sovereign, or son to the sovereign of one of those empires, and why, being possessed of such sur-

prising treasures, he had come with nothing but his valet and a little bag?

Whilst the equerry advanced toward the amphitheatre to execute his commission, another valet arrived upon a unicorn. This valet, addressing himself to the young man, said: "Ormar, your father is approaching the end of his life; I am come to acquaint you with it."

The stranger raised his eyes to heaven, whilst tears streamed from them, and answered only by saying, "Let us depart."

The equerry, after having paid Belus' compliments to the conqueror of the lion, to the giver of the forty diamonds, and to the master of the beautiful bird, asked the valet, "Of what kingdom is the father of this young hero sovereign?"

The valet replied:

"His father is an old shepherd, who is much beloved in his district."

During this conversation, the stranger had already mounted his unicorn. He said to the equerry:

"My lord, vouchsafe to prostrate me at the feet of King Belus and his daughter. I must entreat her to take particular care of the bird I leave with her, as it is a nonpareil like herself."

In uttering these last words he set off, and flew like lightning. The two valets followed him, and in an instant he was out of sight.

Formosanta could not refrain from shrieking.

The bird, turning toward the amphitheatre where his master had been seated, seemed greatly afflicted to find him gone; then viewing steadfastly the princess, and gently rubbing her beautiful hand with his bill, he seemed to devote himself to her service.

Belus, more astonished than ever, hearing that this very extraordinary young man was the son of a shepherd, could not believe it. He despatched messengers after him, but they soon returned with the information that the three unicorns upon which these men were mounted could not be overtaken, and that, according to the rate they went they must go a hundred leagues a day.

Every one reasoned upon this strange adventure, and wearied themselves with conjectures. How can the son of a shepherd make a present of forty large diamonds? How comes it that he is mounted upon a unicorn? This bewildered them, and Formosanta, whilst she caressed her bird, was sunk into a profound reverie.

CHAPTER II.

THE KING OF BABYLON CONVENES HIS COUNCIL AND CONSULTS THE ORACLE.

Princess Aldea, Formosanta's cousin-german, who was very well shaped, and almost as handsome as the king's daughter, said to her:

"Cousin, I know not whether this demi-god be the son of a shepherd, but methinks he has fulfilled all

the conditions stipulated for your marriage. He has
bent Nimrod's bow; he has conquered the lion; he
has a good share of sense, having written for you
extempore a very pretty madrigal. After having
presented you with forty large diamonds, you cannot
deny that he is the most generous of men. In his
bird he possessed the most curious thing upon earth.
His virtue cannot be equalled, since he departed with-
out hesitation as soon as he learned his father was
ill, though he might have remained and enjoyed the
pleasure of your society. The oracle is fulfilled in
every particular, except that wherein he is to over-
come his rivals. But he has done more; he has saved
the life of the only competitor he had to fear; and
when the object is to surpass the other two, I believe
you cannot doubt that he will easily succeed."

"All that you say is very true," replied Formo-
santa, "but is it possible that the greatest of men, and
perhaps the most amiable too, should be the son of a
shepherd?"

The lady of honor, joining in the conversation,
said that the title of shepherd was frequently given to
kings; that they were called shepherds because they
attended very closely to their flocks; that this was
doubtless a piece of ill-timed pleasantry in his valet;
that this young hero had not come so badly equipped,
but to show how much his personal merit alone was
above the fastidious parade of kings. The princess
made no answer, but in giving her bird a thousand
tender kisses.

A great festival was nevertheless prepared for the three kings, and for all the princes who had come to the feast. The king's daughter and niece were to do the honors. The king distributed presents worthy the magnificence of Babylon. Belus, during the time the repast was being served, assembled his council to discuss the marriage of the beautiful Formosanta, and this is the way he delivered himself as a great politician:

"I am old; I know not what is best to do with my daughter, or upon whom to bestow her. He who deserves her is nothing but a mean shepherd. The kings of India and Egypt are cowards. The king of the Scythians would be very agreeable to me, but he has not performed any one of the conditions imposed. I will again consult the oracle. In the meantime, deliberate among you, and we will conclude agreeably to what the oracle says; for a king should follow nothing but the dictates of the immortal gods."

He then repaired to the temple; the oracle answered in few words according to custom: "Thy daughter shall not be married until she hath traversed the globe." In astonishment, Belus returned to the council, and related this answer.

All the ministers had a profound respect for oracles. They therefore all agreed, or at least appeared to agree, that they were the foundation of religion; that reason should be mute before them; that it was by their means that kings reigned over their people;

that without oracles there would be neither virtue nor repose upon earth.

At length, after having testified the most profound veneration for them, they nearly all concluded that this oracle was impertinent, and should not be obeyed; that nothing could be more indecent for a young woman, and particularly the daughter of the great king of Babylon, than to run about, without any particular destination; that this was the most certain method to prevent her being married, or else engage her in a clandestine, shameful, and ridiculous union; that, in a word, this oracle had not common sense.

The youngest of the ministers, named Onadase, who had more sense than the rest, said that the oracle doubtless meant some pilgrimage of devotion, and offered to be the princess' guide. The council approved of his opinion, but every one was for being her equerry. The king determined that the princess might go three hundred parasangs upon the road to Arabia, to the temple whose saint had the reputation of procuring young women happy marriages, and that the dean of the council should accompany her. After this determination they went to supper.

CHAPTER III.

ROYAL FESTIVAL GIVEN IN HONOR OF THE KINGLY
VISITORS—THE BIRD CONVERSES ELOQUENTLY WITH
FORMOSANTA.

In the centre of the gardens, between two cascades, an oval saloon, three hundred feet in diameter, was erected, whose azure roof, intersected with golden stars, represented all the constellations and planets, each in its proper station; and this ceiling turned about, as well as the canopy, by machines as invisible as those which direct the celestial spheres. A hundred thousand flambeaux, inclosed in rich crystal cylinders, illuminated the gardens and the dining-hall. A buffet, with steps, contained twenty thousand vases and golden dishes; and opposite the buffet, upon other steps, were seated a great number of musicians. The two amphitheatres were decked out: the one with the fruits of each season, the other with crystal decanters that sparkled with the choicest wines.

The guests took their seats round a table divided into compartments that resembled flowers and fruits, all in precious stones. The beautiful Formosanta was placed between the kings of India and Egypt, the amiable Aldea next the king of Scythia. There were about thirty princes, and each was seated next one of the handsomest ladies of the court. The king of Babylon, who was in the middle, opposite his

daughter, seemed divided between the chagrin of being yet unable to effect her marriage, and the pleasure of still beholding her. Formosanta asked leave to place her bird upon the table next her; the king approved of it.

The music, which continued during the repast, furnished every prince with an opportunity of conversing with his female neighbor. The festival was as agreeable as it was magnificent. A ragout was served before Formosanta, which her father was very fond of. The princess said it should be carried to his majesty. The bird immediately took hold of it, and carried it in a miraculous manner to the king. Never was anything more astonishing witnessed. Belus caressed it as much as his daughter had done. The bird afterward took its flight to return to her. It displayed, in flying, so fine a tail, and its extended wings set forth such a variety of brilliant colors; the gold of its plumage made such a dazzling éclat, that all eyes were fixed upon it. All the musicians were struck motionless, and their instruments afforded harmony no longer. None ate, no one spoke, nothing but a buzzing of admiration was to be heard. The princess of Babylon kissed it during the whole supper, without considering whether there were any kings in the world. Those of India and Egypt felt their spite and indignation rekindle with double force and they resolved speedily to set their three hundred thousand men in motion to obtain revenge.

As for the king of Scythia, he was engaged in

entertaining the beautiful Aldea. His haughty soul despising, without malice, Formosanta's inattention, had conceived for her more indifference than resentment. "She is handsome," said he, "I acknowledge, but she appears to me one of those women who are entirely taken up with their own beauty, and who fancy that mankind are greatly obliged to them when they deign to appear in public. I should prefer an ugly complaisant woman, that exhibited some amiability, to that beautiful statue. You have, madam, as many charms as she possesses, and you, at least, condescend to converse with strangers. I acknowledge to you with the sincerity of a Scythian, that I prefer you to your cousin."

He was, however, mistaken in regard to the character of Formosanta. She was not so disdainful as she appeared. But his compliments were very well received by the princess Aldea. Their conversation became very interesting. They were well contented, and already certain of one another before they left the table. After supper the guests walked in the groves. The king of Scythia and Aldea did not fail to seek for a place of retreat. Aldea, who was sincerity itself, thus declared herself to the prince:

"I do not hate my cousin, though she be handsomer than myself, and is destined for the throne of Babylon. The honor of pleasing you may very well stand in the stead of charms. I prefer Scythia with you to the crown of Babylon without you. But this crown belongs to me by right, if there be any right in

the world; for I am of the elder branch of the Nimrod family, and Formosanta is only of the younger. Her grandfather dethroned mine, and put him to death."

"Such, then, are the rights of inheritance in the royal house of Babylon!" said the Scythian. "What was your grandfather's name?"

"He was called Aldea, like me. My father bore the same name. He was banished to the extremity of the empire with my mother; and Belus, after their death, having nothing to fear from me, was willing to bring me up with his daughter. But he has resolved that I shall never marry."

"I will avenge the cause of your grandfather, of your father, and also your own cause," said the king of Scythia. "I am responsible for your being married. I will carry you off the day after to-morrow by daybreak—for we must dine to-morrow with the king of Babylon—and I will return and support your rights with three hundred thousand men."

"I agree to it," said the beauteous Aldea; and, after having mutually pledged their words of honor, they separated.

The incomparable Formosanta, before retiring to rest, had ordered a small orange tree, in a silver case, to be placed by the side of her bed, that her bird might perch upon it. Her curtains had long been drawn, but she was not in the least disposed to sleep. Her heart was agitated, and her imagination excited. The charming stranger was ever in her thoughts. She fancied she saw him shooting an arrow with

Nimrod's bow. She contemplated him in the act of cutting off the lion's head. She repeated his madrigal. At length, she saw him retiring from the crowd upon his unicorn. Tears, sighs, and lamentations overwhelmed her at this reflection. At intervals she cried out: "Shall I then never see him more? Will he never return?"

"He will surely return," replied the bird from the top of the orange tree. "Can one have seen you once, and not desire to see you again?"

"Heavens! eternal powers! my bird speaks the purest Chaldæan." In uttering these words she drew back the curtains, put out her hand to him, and knelt upon her bed, saying:

"Art thou a god descended upon earth? Art thou the great Oromasdes concealed under this beautiful plumage? If thou art, restore me this charming young man."

"I am nothing but a winged animal," replied the bird, "but I was born at the time when all animals still spoke; when birds, serpents, asses, horses, and griffins conversed familiarly with man. I would not speak before company, lest your ladies of honor should have taken me for a sorcerer. I would not discover myself to any but you."

Formosanta was speechless, bewildered, and intoxicated with so many wonders. Desirous of putting a hundred questions to him at once, she at length asked him how old he was.

"Only twenty-seven thousand nine hundred years

and six months. I date my age from the little revolution of the equinoxes, and which is accomplished in about twenty-eight thousand of your years. There are revolutions of a much greater extent, so are there beings much older than me. It is twenty-two thousand years since I learned Chaldæan in one of my travels. I have always had a very great taste for the Chaldæan language, but my brethren, the other animals, have renounced speaking in your climate."

"And why so, my divine bird?"

"Alas! because men have accustomed themselves to eat us, instead of conversing and instructing themselves with us. Barbarians! should they not have been convinced that, having the same organs with them, the same sentiments, the same wants, the same desires, we have also what is called a soul, the same as themselves; that we are their brothers, and that none should be dressed and eaten but the wicked? We are so far your brothers that the Supreme Being, the Omnipotent and Eternal Being, having made a compact with men, expressly comprehended us in the treaty. He forbade you to nourish yourselves with our blood, and us to suck yours.

"The fables of your ancient Locman, translated into so many languages, will be an eternally existing testimony of the happy commerce you formerly carried on with us. They all begin with these words: 'In the time when beasts spoke.' It is true, there are many families among you who keep up an incessant conversation with their dogs; but the dogs have

resolved not to answer, since they have been compelled by whipping to go hunting and become accomplices in the murder of our ancient and common friends, stags, deers, hares, and partridges.

"You have still some ancient poems in which horses speak, and your coachmen daily address them in words; but in so barbarous a manner, and in uttering such infamous expressions, that horses, though formerly entertaining so great a kindness for you, now detest you.

"The country which is the residence of your charming stranger, the most perfect of men, is the only one in which your species has continued to love ours, and to converse with us; and is the only country in the world where men are just."

"And where is the country of my dear incognito? What is the name of his empire? For I will no more believe he is a shepherd than that you are a bat."

"His country is that of the Gangarids, a wise, virtuous, and invincible people, who inhabit the eastern shore of the Ganges. The name of my friend is Amazan. He is no king; and I know not whether he would so humble himself as to be one. He has too great a love for his fellow countrymen. He is a shepherd like them. But do not imagine that those shepherds resemble yours, who, covered with rags and tatters, watch their sheep, who are better clad than themselves; who groan under the burden of poverty, and who pay to an extortioner half the

miserable stipend of wages which they receive from
their masters. The Gangaridian shepherds are all
born equal, and own the innumerable herds which
cover their vast fields and subsist on the abundant
verdure. These flocks are never killed. It is a horrid
crime, in that favored country, to kill and eat a fellow
creature. Their wool is finer and more brilliant than
the finest silk, and constitutes the greatest traffic of
the East. Besides, the land of the Gangarids pro-
duces all that can flatter the desires of man. Those
large diamonds that Amazan had the honor of pre-
senting to you are from a mine that belongs to him. A
unicorn, on which you saw him mounted, is the usual
animal the Gangarids ride upon. It is the finest, the
proudest, most terrible, and at the same time most
gentle animal that ornaments the earth. A hundred
Gangarids, with as many unicorns, would be suffi-
cient to disperse innumerable armies. Two centuries
ago a king of India was mad enough to attempt to
conquer this nation. He appeared, followed by ten
thousand elephants and a million of warriors. The
unicorns pierced the elephants, just as I have seen
upon your table beads pierced in golden brochets.
The warriors fell under the sabres of the Gangarids
like crops of rice mowed by the people of the East.
The king was taken prisoner, with upward of six
thousand men. He was bathed in the salutary water
of the Ganges, and followed the regimen of the
country, which consists only of vegetables, of which
nature has there been amazingly liberal to nourish

every breathing creature. Men who are fed with carnivorous aliments, and drenched with spirituous liquors, have a sharp adust blood, which turns their brains a hundred different ways. Their chief rage is a fury to spill their brother's blood, and, laying waste fertile plains, to reign over churchyards. Six full months were taken up in curing the king of India of his disorder. When the physicians judged that his pulse had become natural, they certified this to the council of the Gangarids. The council then followed the advice of the unicorns and humanely sent back the king of India, his silly court, and impotent warriors to their own country. This lesson made them wise, and from that time the Indians respected the Gangarids, as ignorant men, willing to be instructed, revere the philosophers they cannot equal.

"Apropos, my dear bird," said the princess to him, "do the Gangarids profess any religion? have they one?"

"Yes, we meet to return thanks to God on the days of the full moon; the men in a great temple made of cedar, and the women in another, to prevent their devotion being diverted. All the birds assemble in a grove, and the quadrupeds on a fine down. We thank God for all the benefits he has bestowed upon us. We have in particular some parrots *that preach wonderfully well.*

"Such is the country of my dear Amazan; there I reside. My friendship for him is as great as the love

with which he has inspired you. If you will credit me, we will set out together, and you shall pay him a visit."

"Really, my dear bird, this is a very pretty invitation of yours," replied the princess smiling, and who flamed with desire to undertake the journey, but did not dare say so.

"I serve my friend," said the bird; "and, after the happiness of loving you, the greatest pleasure is to assist you."

Formosanta was quite fascinated. She fancied herself transported from earth. All she had seen that day, all she then saw, all she heard, and particularly what she felt in her heart, so ravished her as far to surpass what those fortunate Mussulmans now feel, who, disencumbered from their terrestrial ties, find themselves in the ninth heaven in the arms of their Houris, surrounded and penetrated with glory and celestial felicity.

CHAPTER IV.

THE BEAUTIFUL BIRD IS KILLED BY THE KING OF EGYPT —FORMOSANTA BEGINS A JOURNEY—ALDEA ELOPES WITH THE KING OF SCYTHIA.

Formosanta passed the whole night in speaking of Amazan. She no longer called him anything but her shepherd; and from this time it was that the names of shepherd and lover were indiscriminately used throughout every nation.

Sometimes she asked the bird whether Amazan had had any other mistresses. It answered, "No," and she was at the summit of felicity. Sometimes she asked how he passed his life; and she, with transport, learned that it was employed in doing good, in cultivating arts, in penetrating into the secrets of nature and improving himself. She at times wanted to know if the soul of her lover was of the same nature as that of her bird; how it happened that it had lived twenty thousand years, when her lover was not above eighteen or nineteen. She put a hundred such questions, to which the bird replied with such discretion as excited her curiosity. At length sleep closed their eyes, and yielded up Formosanta to the sweet delusion of dreams sent by the gods, which sometimes surpass reality itself, and which all the philosophy of the Chaldæans can scarce explain.

Formosanta did not awaken till very late. The day was far advanced when the king, her father, entered her chamber. The bird received his majesty with respectful politeness, went before him, fluttered his wings, stretched his neck, and then replaced himself upon his orange tree. The king seated himself upon his daughter's bed, whose dreams had made her still more beautiful. His large beard approached her lovely face, and after having embraced her, he spoke to her in these words:

"My dear daughter, you could not yesterday find a husband agreeable to my wishes; you nevertheless must marry: the prosperity of my empire requires

it. I have consulted the oracle, which you know never errs, and which directs all my conduct. His commands are that you should traverse the globe. You must therefore begin your journey."

"Ah! doubtless to the Gangarids," said the princess; and in uttering these words, which escaped her, she was sensible of her indiscretion. The king, who was utterly ignorant of geography, asked her what she meant by the Gangarids? She easily diverted the question. The king told her she must go on a pilgrimage, that he had appointed the persons who were to attend her—the dean of the counsellors of state, the high almoner, a lady of honor, a physician, an apothecary, her bird, and all necessary domestics.

Formosanta, who had never been out of her father's palace, and who, till the arrival of the three kings and Amazan, had led a very insipid life, according to the etiquette of rank and the parade of pleasure, was charmed at setting out upon a pilgrimage. "Who knows," said she, whispering to her heart, "if the gods may not inspire Amazan with the like desire of going to the same chapel, and I may have the happiness of again seeing the pilgrim?" She affectionately thanked her father, saying she had always entertained a secret devotion for the saint she was going to visit.

Belus gave an excellent dinner to his guests, who were all men. They formed a very ill-assorted company—kings, ministers, princes, pontiffs—all jealous of each other; all weighing their words and

equally embarrassed with their neighbors and themselves. The repast was very gloomy, though they drank pretty freely. The princesses remained in their apartments, each meditating upon her respective journey. They dined at their little cover. For mosanta afterward walked in the gardens with her dear bird, which, to amuse her, flew from tree to tree, displaying his superb tail and divine plumage.

The king of Egypt, who was heated with wine, not to say drunk, asked one of his pages for a bow and arrow. This prince was, in truth, the most unskilful archer in his whole kingdom. When he shot at a mark, the place of greatest safety was generally the spot he aimed at. But the beautiful bird, flying as swiftly as the arrow, seemed to court it, and fell bleeding in the arms of Formosanta. The Egyptian, bursting into a foolish laugh, retired to his place. The princess rent the skies with her moans, melted into tears, tore her hair, and beat her breast. The dying bird said to her, in a low voice: "Burn me, and fail not to carry my ashes to the east of the ancient city of Aden or Eden, and expose them to the sun upon a little pile of cloves and cinnamon." After having uttered these words it expired. Formosanta was for a long time in a swoon, and revived again only to burst into sighs and groans. Her father, partaking of her grief, and imprecating the king of Egypt, did not doubt that this accident foretold some fatal event. He immediately went to consult

the oracle, which replied: "A mixture of everything
—life and death, infidelity and constancy, loss and
gain, calamities and good fortune." Neither he nor
his council could comprehend any meaning in this re-
ply; but, at length, he was satisfied with having ful-
filled the duties of devotion.

His daughter was bathed in tears, while he con-
sulted the oracle. She paid the funeral obsequies to
the bird, which it had directed, and resolved to carry
its remains into Arabia at the risk of her life. It
was burned in incombustible flax, with the orange-
tree on which it used to perch. She gathered up
the ashes in a little golden vase, set with rubies, and
the diamonds taken from the lion's mouth. Oh!
that she could, instead of fulfilling this melancholy
duty, have burned alive the detestable king of
Egypt! This was her sole wish. She, in spite, put
to death the two crocodiles, his two sea horses, his
two zebras, his two rats, and had his two mummies
thrown into the Euphrates. Had she possessed his
bull Apis, she would not have spared him.

The king of Egypt, enraged at this affront, set out
immediately to forward his three hundred thousand
men. The king of India, seeing his ally depart,
set off also on the same day, with a firm intention of
joining his three hundred thousand Indians to the
Egyptian army. The king of Scythia decamped
in the night with the Princess Aldea, fully resolved
to fight for her at the head of three hundred thou-

sand Scythians, and to restore to her the inheritance of Babylon, which was her right, as she had descended from the elder branch of the Nimrod family.

As for the beautiful Formosanta, she set out at three in the morning with her caravan of pilgrims, flattering herself that she might go into Arabia, and execute the last will of her bird; and that the justice of the gods would restore her the dear Amazan, without whom life had become insupportable.

When the king of Babylon awoke, he found all the company gone.

"How mighty festivals terminate," said he; "and what a surprising vacuum they leave when the hurry is over."

But he was transported with a rage truly royal, when he found that the Princess Aldea had been carried off. He ordered all his ministers to be called up, and the council to be convened. While they were dressing, he failed not to consult the oracle; but the only answer he could obtain was in these words, so celebrated since throughout the universe: "When girls are not provided for in marriage by their relatives, they marry themselves."

Orders were immediately issued to march three hundred thousand men against the king of Scythia. Thus was the torch of a most dreadful war lighted up, which was caused by the amusements of the finest festival ever given upon earth. Asia was upon the point of being overrun by four armies of three hun-

dred thousand men each. It is plain that the war of
Troy, which astonished the world some ages after,
was mere child's play in comparison to this : but it
should also be considered, that in the Trojans' quar-
rel, the object was nothing more than a very im-
moral old woman, who had contrived to be twice
run away with ; whereas, in this case, the cause was
tripartite—two girls and a bird.

The king of India went to meet his army upon
the large, fine road which then led straight to Baby-
lon, at Cachemir. The king of Scythia flew with
Aldea by the fine road which led to Mount Imaus.
Owing to bad government, all these fine roads have
disappeared in the lapse of time. The king of
Egypt had marched to the west, along the coast of
the little Mediterranean sea, which the ignorant He-
brews have since called the Great Sea.

As to the charming Formosanta, she pursued the
road to Bassora, planted with lofty palm trees, which
furnished a perpetual shade, and fruit at all seasons.
The temple in which she was to perform her devo-
tions, was in Bassora itself. The saint to whom
this temple had been dedicated was somewhat in the
style of him who was afterwards adored at Lamp-
sacus, and was generally successful in procuring hus-
bands for young ladies. Indeed, he was the holiest
saint in all Asia.

Formosanta had no sort of inclination for the saint
of Bassora. She only invoked her dear Gangaridian

shepherd, her charming Amazan. She proposed embarking at Bassora, and landing in Arabia Felix, to perform what her deceased bird had commanded.

At the third stage, scarce had she entered into a fine inn, where her harbingers had made all the necessary preparations for her, when she learned that the king of Egypt had arrived there also. Informed by his emissaries of the princess' route, he immediately altered his course, followed by a numerous escort. Having alighted, he placed sentinels at all the doors; then repaired to the beautiful Formosanta's apartment, when he addressed her by saying:

"Miss, you are the lady I was in quest of. You paid me very little attention when I was at Babylon. It is just to punish scornful, capricious women. You will, if you please, be kind enough to sup with me to-night; and I shall behave to you according as I am satisfied with you."

Formosanta saw very well that she was not the strongest. She judged that good sense consisted in knowing how to conform to one's situation. She resolved to get rid of the king of Egypt by an innocent stratagem. She looked at him through the corners of her eyes—which in after ages has been called ogling—and then she spoke to him, with a modesty, grace, and sweetness, a confusion, and a thousand other charms, which would have made the wisest man a fool, and deceived the most discerning:

"I acknowledge, sir, I always appeared with a downcast look, when you did the king, my father,

the honor of visiting him. I had some apprehensions for my heart. I dreaded my too great simplicity. I trembled lest my father and your rivals should observe the preference I gave you, and which you so highly deserved. I can now declare my sentiments. I swear by the bull Apis, which after you is the thing I respect the most in the world, that your proposals have enchanted me. I have already supped with you at my father's, and I will sup with you again, without his being of the party. All that I request of you is that your high almoner should drink with us. He appeared to me at Babylon to be an excellent guest. I have some Chiras wine remarkably good. I will make you both taste it. I consider you as the greatest of kings, and the most amiable of men."

This discourse turned the king of Egypt's head. He agreed to have the almoner's company.

"I have another favor to ask of you," said the princess, "which is to allow me to speak to my apothecary. Women have always some little ails that require attention, such as vapors in the head, palpitations of the heart, colics, and the like, which often require some assistance. In a word, I at present stand in need of my apothecary, and I hope you will not refuse me this slight testimony of confidence."

"Miss," replied the king of Egypt, "I know life too well to refuse you so just a demand. I will order the apothecary to attend you while supper is preparing. I imagine you must be somewhat fatigued by the journey; you will also have occasion for a

chambermaid; you may order her you like best to attend you. I will afterwards wait your commands and convenience."

He then retired, and the apothecary and the chambermaid, named Irla, entered. The princess had entire confidence in her. She ordered her to bring six bottles of Chiras wine for supper, and to make all the sentinels, who had her officers under arrest, drink the same. Then she recommended her apothecary to infuse in all the bottles certain pharmaceutic drugs, which make those who take them sleep twenty-four hours, and with which he was always provided. She was implicitly obeyed. The king returned with his high almoner in about half an hour's time. The conversation at supper was very gay. The king and the priest emptied the six bottles, and acknowledged there was not such good wine in Egypt. The chambermaid was attentive to make the servants in waiting drink. As for the princess, she took great care not to drink any herself, saying that she was ordered by her physician a particular regimen. They were all presently asleep.

The king of Egypt's almoner had one of the finest beards that a man of his rank could wear. Formosanta lopped it off very skilfully; then sewing it to a ribbon, she put it on her own chin. She then dressed herself in the priest's robes, and decked herself in all the marks of his dignity, and her waiting maid clad herself like the sacristan of the goddess Isis. At length, having furnished herself with his

urn and jewels, she set out from the inn amidst the
sentinels, who were asleep like their master. Her at-
tendant had taken care to have two horses ready at
the door. The princess could not take with her
any of the officers of her train. They would have
been stopped by the great guard.

Formosanta and Irla passed through several ranks
of soldiers, who, taking the princess for the high
priest, called her, "My most Reverend Father in
God," and asked his blessing. The two fugitives ar-
rived in twenty-four hours at Bassora, before the
king awoke. They then threw off their disguise,
which might have created some suspicion. They
fitted out with all possible expedition a ship, which
carried them, by the Straits of Ormus, to the beau-
tiful banks of Eden in Arabia Felix. This was that
Eden whose gardens were so famous that they have
since been the residence of the best of mankind. They
were the model of the Elysian fields, the gardens of
the Hesperides, and also those of the Fortunate
Islands. In those warm climates men imagined there
could be no greater felicity than shades and mur-
muring brooks. To live eternally in heaven with the
Supreme Being, or to walk in the garden of paradise,
was the same thing to those who incessantly spoke
without understanding one another, and who could
scarce have any distinct ideas or just expressions.

As soon as the princess found herself in this land,
her first care was to pay her dear bird the funeral
obsequies he had required of her. Her beautiful

hands prepared a small quantity of cloves and cinnamon. What was her surprise, when, having spread the ashes of the bird upon this funeral pyre, she saw it blaze of itself! All was presently consumed. In the place of the ashes there appeared nothing but a large egg, whence she saw her bird issue more brilliant than ever. This was one of the most happy moments the princess had ever experienced in her whole life. There was but another that could ever be dearer to her; it was the object of her wishes, but almost beyond her hopes.

"I plainly see," said she, to the bird, "you are the phœnix of which I have heard so much spoken. I am almost ready to expire with joy and astonishment. I did not believe in your resurrection; but it is my good fortune to be convinced of it."

"Resurrection, in fact," said the phœnix to her, "is one of the most simple things in the world. There is nothing more in being born twice than once. Everything in this world is the effect of resurrection. Caterpillars are regenerated into butterflies; a kernel put into the earth is regenerated into a tree. All animals buried in earth regenerate into vegetation, herbs, and plants, and nourish other animals, of which they speedily compose part of the substance. All particles which compose bodies are transformed into different beings. It is true, that I am the only one to whom Oromasdes has granted the favor of regenerating my own form."

Formosanta, who, from the moment she first saw

Amazan and the phœnix, had passed all her time in a round of astonishment, said to him:

"I can easily conceive that the Supreme Being may form out of your ashes a phœnix nearly resembling yourself; but that you should be precisely the same person, that you should have the same soul, is a thing, I acknowledge, I cannot very clearly comprehend. What became of your soul when I carried you in my pocket after your death?"

"Reflect one moment! Is it not as easy for the great Oromasdes to continue action upon a single atom of my being as to begin afresh this action? He had before granted me sensation, memory, and thought. He grants them to me again. Whether he united this favor to an atom of elementary fire, latent within me, or to the assemblage of my organs, is, in reality, of no consequence. Men, as well as phœnixes, are entirely ignorant how things come to pass; but the greatest favor the Supreme Being has bestowed upon me is to regenerate me for you. Oh! that I may pass the twenty-eight thousand years which I have still to live before my next resurrection, with you and my dear Amazan."

"My dear phœnix, remember what you first told me at Babylon, which I shall never forget, and which flattered me with the hope of again seeing my dear shepherd, whom I idolize; 'we must absolutely pay the Gangarids a visit together,' and I must carry Amazan back with me to Babylon."

"This is precisely my design," said the phœnix.

"There is not a moment to lose. We must go in search of Amazan by the shortest road, that is, through the air. There are in Arabia Felix two griffins, who are my particular friends, and who live only a hundred and fifty thousand leagues from here. I am going to write to them by the pigeon post, and they will be here before night. We shall have time to make you a convenient palanquin, with drawers, in which you may place your provisions. You will be quite at your ease in this vehicle, with your maid. These two griffins are the most vigorous of their kind. Each of them will support one of the poles of the canopy between their claws. But, once for all time is very precious."

He instantly went with Formosanta to order the carriage from an upholsterer of his acquaintance. It was made complete in four hours. In the drawers were placed small fine loaves, biscuits superior to those of Babylon, large lemons, pineapples, cocoa, and pistachio nuts, Eden wine, which is as superior to that of Chiras, as Chiras is to that of Surinam.

The two griffins arrived at Eden at the appointed time. The vehicle was as light as it was commodious and solid, and Formosanta and Irla placed themselves in it. The two griffins carried it off like a feather. The phœnix sometimes flew after it, and sometimes perched upon its roof. The two griffins winged their way toward the Ganges with the velocity of an arrow which rends the air. They never stopped but a moment at night for the travellers to

take some refreshment, and the carriers to take a draught of water.

They at length reached the country of the Gangarids. The princess' heart palpitated with hope, love and joy. The phœnix stopped the vehicle before Amazan's house; but Amazan had been absent from home three hours, without any one knowing whither he had gone.

There are no words, even in the Gangaridian language, that could express Formosanta's extreme despair.

"Alas! that is what I dreaded," said the phœnix: "the three hours which you passed at the inn, upon the road to Bassora, with that wretched king of Egypt, have perhaps been at the price of the happiness of your whole life. I very much fear we have lost Amazan, without the possibility of recovering him."

He then asked the servants if he could salute the mother of Amazan? They answered, that her husband had died only two days before, and she could speak to no one. The phœnix, who was not without influence in the house, introduced the princess of Babylon into a saloon, the walls of which were covered with orange-tree wood inlaid with ivory. The inferior shepherds and shepherdesses, who were dressed in long, white garments, with gold-colored trimmings, served up, in a hundred plain porcelain baskets, a hundred various delicacies, among which no disguised carcasses were to be seen. They con-

sisted of rice, sago, vermicelli, macaroni, omelets, milk, eggs, cream, cheese, pastry of every kind, vegetables, fruits, peculiarly fragrant and grateful to the taste, of which no idea can be formed in other climates; and they were accompanied with a profusion of refreshing liquors superior to the finest wine.

Whilst the princess regaled herself, seated upon a bed of roses, four peacocks, who were luckily mute, fanned her with their brilliant wings; two hundred birds, one hundred shepherds and shepherdesses, warbled a concert in two different choirs; the nightingales, thistlefinches, linnets, chaffinches, sung the higher notes with the shepherdesses, and the shepherds sung the tenor and bass. The princess acknowledged, that if there was more magnificence at Babylon, nature was infinitely more agreeable among the Gangarids; but while this consolatory and voluptuous music was playing, tears flowed from her eyes, while she said to the damsel Irla:

"These shepherds and shepherdesses, these nightingales, these linnets, are making love; and for my part I am deprived of the company of the Gangaridian hero, the worthy object of my most tender thoughts."

While she was taking this collation, her tears and admiration kept pace with each other, and the phœnix addressed himself to Amazan's mother, saying:

"Madam, you cannot avoid seeing the princess of Babylon; you know—"

"I know everything," said she, "even her adven-

ture at the inn, upon the road to Bassora. A black-bird related the whole to me this morning; and this cruel blackbird is the cause of my son's going mad, and leaving his paternal abode."

"You have not been informed, then, that the princess regenerated me?"

"No, my dear child, the blackbird told me you were dead, and this made me inconsolable. I was so afflicted at this loss, the death of my husband, and the precipitate flight of my son, that I ordered my door to be shut to everyone. But since the princess of Babylon has done me the honor of paying me a visit, I beg she may be immediately introduced. I have matters of great importance to acquaint her with, and I choose you should be present."

She then went to meet the princess in another saloon. She could not walk very well. This lady was about three hundred years old; but she had still some agreeable vestiges of beauty. It might be conjectured, that about her two hundred and fortieth, or two hundred and fiftieth year, she must have been a most charming woman. She received Formosanta with a respectful nobleness, blended with an air of interest and sorrow, which made a very lively impression upon the princess.

Formosanta immediately paid her the compliments of condolence upon her husband's death.

"Alas!" said the widow, "you have more reason to lament his death than you imagine."

"I am, doubtless, greatly afflicted," said Formo-

santa; "he was father to——." Here a flood of
tears prevented her from going on. "For his sake
only I undertook this journey, in which I have so nar-
rowly escaped many dangers. For him I left my
father, and the most splendid court in the universe.
I was detained by a king of Egypt, whom I detest.
Having escaped from this tyrant, I have traversed
the air in search of the only man I love. When I
arrive, he flies from me!" Here sighs and tears
stopped her impassioned harangue.

His mother then said to her:

"When the king of Egypt made you his pris-
oner; when you supped with him at an inn upon
the road to Bassora; when your beautiful hands
filled him bumpers of Chiras wine, did you observe
a blackbird that flew about the room?"

"Yes, really," said the princess, "I now recollect
there was such a bird, though at that time I did not
pay it the least attention. But in collecting my ideas,
I now remember well, that at the instant when the
king of Egypt rose from the table to give me a kiss,
the blackbird flew out at the window giving a loud
cry, and never appeared after."

"Alas! madam," resumed Amazan's mother, "this
is precisely the cause of all our misfortunes; my son
had despatched this blackbird to gain intelligence of
your health, and all that passed at Babylon. He pro-
posed speedily to return, throw himself at your feet,
and consecrate to you the remainder of his life. You
know not to what a pitch he adores you. All the

Gangarids are both loving and faithful; but my son is the most passionate and constant of them all. The blackbird found you at an inn, drinking very cheerfully with the king of Egypt and a vile priest; he afterwards saw you give this monarch who had killed the phœnix—the man my son holds in utter detestation—a fond embrace. The blackbird, at the sight of this, was seized with a just indignation. He flew away imprecating your fatal error. He returned this day, and has related everything. But, just heaven, at what a juncture! At the very time that my son was deploring with me the loss of his father and that of the wise phœnix, the very instant I had informed him that he was your cousin-german—"

"Oh heavens! my cousin, madam, is it possible? How can this be? And am I so happy as to be thus allied to him, and yet so miserable as to have offended him?"

"My son is, I tell you," said the Gangaridian lady, "your cousin, and I shall presently convince you of it; but in becoming my relation, you rob me of my son. He cannot survive the grief that the embrace you gave to the king of Egypt has occasioned him."

"Ah! my dear aunt," cried the beautiful Formosanta, "I swear by him and the all-powerful Oromasdes, that this embrace, so far from being criminal, was the strongest proof of love your son could receive from me. I disobeyed my father for his sake. For him I went from the Euphrates to the Ganges. Having fallen into the hands of the worthless

Pharaoh of Egypt, I could not escape his clutches but by artifice. I call the ashes and soul of the phœnix which were then in my pocket, to witness. He can do me justice. But how can your son, born upon the banks of the Ganges, be my cousin? I, whose family have reigned upon the banks of the Euphrates for so many centuries?"

"You know," said the venerable Gangaridian lady to her, "that your granduncle Aldea was king of Babylon, and that he was dethroned by Belus' father?"

"Yes, madam."

"You know that this Aldea had in marriage a daughter named Aldea, brought up in your court? It was this prince, who, being persecuted by your father, took refuge under another name in our happy country. He married me, and is the father of the young prince Aldea Amazan, the most beautiful, the most courageous, the strongest, and most virtuous of mortals; and at this hour the most unhappy. He went to the Babylonian festival upon the credit of your beauty; since that time he idolizes you, and now grieves because he believes that you have proved unfaithful to him. Perhaps I shall never again set eyes upon my dear son."

She then displayed to the princess all the titles of the house of Aldea. Formosanta scarce deigned to look at them.

"Ah! madam, do we examine what is the object

of our desire? My heart sufficiently believes you.
But where is Aldea Amazan? Where is my kinsman,
my lover, my king? Where is my life? What road
has he taken? I will seek for him in every sphere
the Eternal Being has framed, and of which he is the
greatest ornament. I will go into the star Canope,
into Sheath, into Aldebaran; I will go and tell him
of my love and convince him of my innocence."

The phœnix justified the princess with regard to
the crime that was imputed to her by the blackbird,
of fondly embracing the king of Egypt; but it was
necessary to undeceive Amazan and recall him.
Birds were despatched on every side. Unicorns were
sent forward in every direction. News at length
arrived that Amazan had taken the road towards
China.

"Well, then," said the princess, "let us set out
for China. I will seek him in defiance of both dif-
ficulty and danger. The journey is not long, and I
hope I shall bring you back your son in a fortnight
at farthest."

At these words tears of affection streamed from
his mother's eyes and also from those of the princess.
They most tenderly embraced, in the great sensibility
of their hearts.

The phœnix immediately ordered a coach with
six unicorns. Amazan's mother furnished two thou-
sand horsemen, and made the princess, her niece, a
present of some thousands of the finest diamonds of

her country. The phœnix, afflicted at the evil occasioned by the blackbird's indiscretion, ordered all the blackbirds to quit the country; and from that time none have been met with upon the banks of the Ganges.

CHAPTER V

FORMOSANTA VISITS CHINA AND SCYTHIA IN SEARCH OF AMAZAN.

The unicorn, in less than eight days, carried Formosanta, Irla, and the phœnix, to Cambalu, the capital of China. This city was larger than Babylon, and in appearance quite different. These fresh objects, these strange manners, would have amused Formosanta could anything but Amazan have engaged her attention.

As soon as the emperor of China learned that the princess of Babylon was at the city gates, he despatched four thousand mandarins in ceremonial robes to receive her. They all prostrated themselves before her, and presented her with an address written in golden letters upon a sheet of purple silk. Formosanta told them, that if she were possessed of four thousand tongues, she would not omit replying immediately to every mandarin; but that having only one, she hoped they would be satisfied with her general thanks. They conducted her, in a respectful manner, to the emperor.

He was the wisest, most just and benevolent monarch upon earth. It was he who first tilled a small field with his own imperial hands, to make agriculture respectable to his people. Laws in all other countries were shamefully confined to the punishment of crimes: he first allotted premiums to virtue. This emperor had just banished from his dominions a gang of foreign Bonzes, who had come from the extremities of the West, with the frantic hope of compelling all China to think like themselves; and who, under pretence of teaching truths, had already acquired honors and riches. In expelling them, he delivered himself in these words, which are recorded in the annals of the empire:

You may here do as much harm as you have elsewhere. You have come to preach dogmas of intolerance to the most tolerant nation upon earth. I send you back, that I may never be compelled to punish you. You will be honorably conducted to my frontiers. You will be furnished with everything necessary to return to the confines of the hemisphere whence you came. Depart in peace, if you can be at peace, and never return.

The princess of Babylon heard with pleasure of this speech and determination. She was the more certain of being well received at court, as she was very far from entertaining any dogmas of intolerance. The emperor of China, in dining with her tête-à-tête, had the politeness to banish all disagreeable etiquette. She presented the phœnix to him, who was gently caressed by the emperor, and who perched upon his chair. Formosanta, towards the end of the repast, ingenuously acquainted him with the cause of her

journey, and entreated him to search for the beautiful Amazan in the city of Cambalu; and meanwhile she acquainted the emperor with her adventures, without concealing the fatal passion with which her heart burned for this youthful hero.

"He did me the honor of coming to my court," said the emperor of China. "I was enchanted with this amiable Amazan. It is true that he is deeply afflicted; but his graces are thereby the more affecting. Not one of my favorites has more wit. There is not a gown mandarin who has more knowledge, not a military one who has a more martial or heroic air. His extreme youth adds an additional value to all his talents. If I were so unfortunate, so abandoned by the Tien and Changti, as to desire to be a conqueror, I would wish Amazan to put himself at the head of my armies, and I should be sure of conquering the whole universe. It is a great pity that his melancholy sometimes disconcerts him."

"Ah! sir," said Formosanta, with much agitation and grief, blended with an air of reproach, "why did you not request me to dine with him? This is a cruel stroke you have given me. Send for him immediately, I entreat you."

"He set out this very morning," replied the emperor, "without acquainting me with his destination."

Formosanta, turning towards the phœnix, said to him:

"Did you ever know so unfortunate a damsel as myself?" Then resuming the conversation, she said:

"Sir, how came he to quit in so abrupt a manner so polite a court, in which, methinks, one might pass one's life?"

"The case was as follows," said he. "One of the most amiable of the princesses of the blood, falling desperately in love with him, desired to meet him at noon. He set out at daybreak, leaving this billet for my kinswoman, whom it hath cost a deluge of tears:

Beautiful princess of the Mongolian race:—You are deserving of a heart that was never offered up at any other altar. I have sworn to the immortal gods never to love any other than Formosanta, princess of Babylon, and to teach her how to conquer one's desires in travelling. She has had the misfortune to yield to a worthless king of Egypt. I am the most unfortunate of men, having lost my father, the phœnix, and the hope of being loved by Formosanta. I left my mother in affliction, forsook my home and country, being unable to live a moment in the place where I learned that Formosanta loved another than me. I swore to traverse the earth, and be faithful. You would despise me, and the gods punish me, if I violated my oath. Choose another lover, madam, and be as faithful as I am.

"Ah! give me that miraculous letter," said the beautiful Formosanta; "it will afford me some consolation. I am happy in the midst of my misfortunes. Amazan loves me! Amazan, for me, renounces the society of the princesses of China. There is no one upon earth but himself endowed with so much fortitude. He sets me a most brilliant example. The phœnix knows I did not stand in need of it. How cruel it is to be deprived of one's lover for the most

innocent embrace given through pure fidelity. But, tell me, whither has he gone? What road has he taken? Deign to inform me, and I will immediately set out."

The emperor of China told her that, according to the reports he had received, her lover had taken the road toward Scythia. The unicorns were immediately harnessed, and the princess, after the most tender compliments, took leave of the emperor, and resumed her journey with the phœnix, her chambermaid Irla, and all her train.

As soon as she arrived in Scythia, she was more convinced than ever how much men and governments differed, and would continue to differ, until noble and enlightened minds should by degrees remove that cloud of darkness which has covered the earth for so many ages; and until there should be found in barbarous climes, heroic souls who would have strength and perseverance enough to transform brutes into men. There are no cities in Scythia, consequently no agreeable arts. Nothing was to be seen but extensive fields, and whole tribes whose sole habitations were tents and chars. Such an appearance struck her with terror. Formosanta inquired in what tent or char the king was lodged? She was informed that he had set out eight days before with three hundred thousand cavalry to attack the king of Babylon, whose niece, the beautiful Princess Aldea, he had carried off.

"What! did he run away with my cousin?" cried

Formosanta. "I could not have imagined such an incident. What! has my cousin, who was too happy in paying her court to me, become a queen, and I am not yet married?" She was immediately conducted, by her desire, to the queen's tent.

Their unexpected meeting in such distant climes; the uncommon occurrences they mutually had to impart to each other, gave such charm to this interview as made them forget they never loved one another. They saw each other with transport; and a soft illusion supplied the place of real tenderness. They embraced with tears, and there was a cordiality and frankness on each side that could not have taken place in a palace.

Aldea remembered the phœnix and the waiting maid Irla. She presented her cousin with zibeline skins, who in return gave her diamonds. The war between the two kings was spoken of. They deplored the fate of soldiers who were forced into battle, the victims of the caprice of princes, when two honest men might, perhaps, settle the dispute in less than an hour, without a single throat being cut. But the principal topic was the handsome stranger, who had conquered lions, given the largest diamonds in the universe, written madrigals, and had now become the most miserable of men from believing the statements of a blackbird.

"He is my dear brother," said Aldea. "He is my lover," cried Formosanta. "You have doubtless seen him. Is he still here? For, cousin, as he

knows he is your brother, he cannot have left you so abruptly as he did the king of China."

"Have I seen him? Good heavens! yes. He passed four whole days with me. Ah! cousin, how much my brother is to blame. A false report has absolutely turned his brain. He roams about the world, without knowing whither he is destined. Imagine to yourself his distraction of mind, which is so great that he has refused to meet the handsomest lady in all Scythia. He set out yesterday, after writing her a letter which has thrown her into despair. As for him, he has gone to visit the Cimmerians."

"God be thanked!" cried Formosanta; "another refusal in my favor. My good fortune is beyond my hopes, as my misfortunes surpass my greatest apprehensions. Procure me this charming letter that I may set out and follow him, loaded with his sacrifices. Farewell, cousin. Amazan is among the Cimmerians, and I fly to meet him."

Aldea judged that the princess, her cousin, was still more frantic than her brother Amazan. But as she had herself been sensible of the effects of this epidemic contagion, having given up the delights and magnificence of Babylon for a king of Scythia; and as the women always excuse those follies that are the effects of love, she felt for Formosanta's affliction, wished her a happy journey, and promised to be her advocate with her brother, if ever she was so fortunate as to see him again.

CHAPTER VI.

THE PRINCESS CONTINUES HER JOURNEY.

From Scythia the princess of Babylon, with her phœnix, soon arrived at the empire of the Cimmerians, now called Russia; a country indeed much less populous than Scythia, but of far greater extent.

After a few days' journey she entered a very large city, which has of late been greatly improved by the reigning sovereign. The empress, however, was not there at that time, but was making a journey through her dominions on the frontiers of Europe and Asia, in order to judge of their state and condition with her own eyes, to inquire into their grievances, and to provide the proper remedies for them.

The principal magistrate of that ancient capital, as soon as he was informed of the arrival of the Babylonian lady and the phœnix, lost no time in paying her all the honors of his country; being certain that his mistress, the most polite and generous empress in the world, would be extremely well pleased to find that he had received so illustrious a lady with all that respect which she herself, if on the spot, would have shown her.

The princess was lodged in the palace and entertained with great splendor and elegance. The Cimmerian lord, who was an excellent natural philosopher, diverted himself in conversing with the

phœnix at such times as the princess chose to retire to her own apartment. The phœnix told him that he had formerly travelled among the Cimmerians, but that he should not have known the country again.

"How comes it," said he, "that such prodigious changes have been brought about in so short a time? Formerly, when I was here, about three hundred years ago, I saw nothing but savage nature in all her horrors. At present, I perceive industry, arts, splendor, and politeness."

"This mighty revolution," replied the Cimmerian, "was begun by one man, and is now carried to perfection by one woman; a woman who is a greater legislator than the Isis of the Egyptians or the Ceres of the Greeks. Most lawgivers have been, unhappily, of a narrow genius and an arbitrary disposition, which confined their views to the countries they governed. Each of them looked upon his own race as the only people existing upon the earth, or as if they ought to be at enmity with all the rest. They formed institutions, introduced customs, and established religions exclusively for themselves. Thus the Egyptians, so famous for those heaps of stones called pyramids, have dishonored themselves with their barbarous superstitions. They despise all other nations as profane; refuse all manner of intercourse with them; and, excepting those conversant in the court, who now and then rise above the prejudices of the vulgar, there is not an Egyptian who will eat off a plate that has ever been used by a stranger. Their

priests are equally cruel and absurd. It were better to have no laws at all, and to follow those notions of right and wrong engraved on our hearts by nature, than to subject society to institutions so inhospitable.

"Our empress has adopted quite a different system. She considers her vast dominions, under which all the meridians on the globe are united, as under an obligation of correspondence with all the nations dwelling under those meridians. The first and most fundamental of her laws is a universal toleration of all religions, and an unbounded compassion for every error. Her penetrating genius perceives that though the modes of religious worship differ, yet morality is everywhere the same. By this principal she has united her people to all the nations on earth, and the Cimmerians will soon consider the Scandinavians and the Chinese as their brethren. Not satisfied with this, she has resolved to establish this invaluable toleration, the strongest link of society, among her neighbors. By these means she obtained the title of the parent of her country; and, if she persevere, will acquire that of the benefactress of mankind.

"Before her time, the men, who were unhappily possessed of power, sent out legions of murderers to ravage unknown countries, and to water with the blood of the children the inheritance of their fathers. Those assassins were called heroes, and their robberies accounted glorious achievements. But our

sovereign courts another sort of glory. She has sent forth her armies to be the messengers of peace, not only to prevent men from being the destroyers, but to oblige them to be the benefactors of one another. Her standards are the ensigns of public tranquillity."

The phœnix was quite charmed with what he heard from this nobleman. He told him that though he had lived twenty-seven thousand nine hundred years and seven months in this world he had never seen anything like it. He then inquired after his friend Amazan. The Cimmerian gave the same account of him that the princess had already heard from the Chinese and the Scythians. It was Amazan's constant practice to run away from all the courts he visited the instant any lady noticed him in particular and seemed anxious to make his acquaintance. The phœnix soon acquainted Formosanta with this fresh instance of Amazan's fidelity —a fidelity so much the more surprising since he could not imagine his princess would ever hear of it.

Amazan had set out for Scandinavia, where he was entertained with sights still more surprising. In this place he beheld monarchy and liberty existing together in a manner thought incompatible in other states; the laborers of the ground shared in the legislature with the grandees of the realm. In another place he saw what was still more extraordinary—a prince equally remarkable for his extreme youth and uprightness, who possessed a sov-

ereign authority over his country acquired by a
solemn contract with his people.

Amazan beheld a philosopher on the throne of
Sarmatia, who might be called a king of anarchy;
for he was the chief of a hundred thousand petty
kings, one of whom with his single voice could render
ineffectual the resolution of all the rest. Æolus had
not more difficulty to keep the warring winds within
their proper bounds than this monarch had to recon-
cile the tumultuous discordant spirits of his subjects.
He was the master of a ship surrounded with eternal
storms. But the vessel did not founder, for he
was an excellent pilot.

In traversing those various countries, so different
from his own, Amazan persevered in rejecting all
the advances made to him by the ladies, though in-
cessantly distracted with the embrace given by For-
mosanta to the king of Egypt, being resolved to set
Formosanta an amazing example of an unshaken
and unparalleled fidelity.

The princess of Babylon was constantly close at
his heels, and scarcely ever missed him but by a day
or two; without the one being tired of roaming, or
the other losing a moment in pursuing him.

Thus he traversed the immense continent of Ger-
many, where he beheld with wonder the progress
which reason and philosophy had made in the north.
Even their princes were enlightened and had be-
come the patrons of freedom of thought. Their
education had not been trusted to men who had an

interest in deceiving them, or who were themselves deceived. They were brought up in the knowledge of universal morality, and in the contempt of superstition.

They had banished from all their estates a senseless custom which had enervated and depopulated the southern countries. This was to bury alive in immense dungeons, infinite numbers of both sexes who were eternally separated from one another, and sworn to have no communication togther. This madness had contributed more than the most cruel wars to lay waste and depopulate the earth.

In opposing these barbarous institutions so inimical to the laws of nature and the best interests of society, the princes of the north had become the benefactors of their race. They had likewise exploded other errors equally absurd and pernicious. In short, men had at last ventured to make use of their reason in those immense regions; whereas it was still believed almost everywhere else that they could not be governed but in proportion to their ignorance.

CHAPTER VII.

AMAZAN VISITS ALBION.

From Germany, Amazan arrived at Batavia, where his perpetual chagrin was in a great measure alleviated by perceiving among the inhabitants a faint resemblance to his happy countrymen, the Gan-

garids. There he saw liberty, security and equality, with toleration in religion; but the ladies were so indifferent that none made him any advances, an experience he had not met with before. It is true, however, that had he been inclined to address them they would not have been offended; though, at the same time, not one would have been the least in love; but he was far from any thoughts of making conquests.

Formosanta had nearly caught him in this insipid nation. He had set out but a moment before her arrival.

Amazan had heard so much among the Batavians in praise of a certain island called Albion that he was led by curiosity to embark with his unicorns on board a ship, which, with a favorable easterly wind, carried him in a few hours to that celebrated country, more famous than Tyre or Atlantis.

The beautiful Formosanta, who had followed him, as it were on the scent, to the banks of the Volga, the Vistula, the Elbe, and the Weser, and had never been above a day or two behind him, arrived soon after at the mouth of the Rhine, where it empties its waters into the German ocean.

Here she learned that her beloved Amazan had just set sail for Albion. She thought she saw the vessel on board of which he was, and could not help crying out for joy, at which the Batavian ladies were greatly surprised, not imagining that a young man could possibly occasion so violent a transport.

They took, indeed, but little notice of the phœnix, as they reckoned his feathers would not fetch nearly so good a price as those of their own ducks and other water-fowl. The princess of Babylon hired two vessels to carry herself and her retinue to that happy island which was soon to possess the only object of her desires, the soul of her life, and the god of her idolatry.

An unpropitious wind from the west suddenly arose, just as the faithful and unhappy Amazan landed on Albion's sea-girt shore, and detained the ships of the Babylonian princess just as they were on the point of sailing. Seized with a deep melancholy, she went to her room, determined to remain there till the wind should change; but it blew for the space of eight days with an unremitting violence. The princess, during this tedious period, employed her maid of honor, Irla, in reading romances; which were not indeed written by the Batavians; but as they are the factors of the universe they traffic in the wit as well as commodities of other nations. The princess purchased of Mark Michael Rey, the bookseller, all the novels which had been written by the Ausonians and the Welsh, the sale of which had been wisely prohibited among those nations to enrich their neighbors, the Batavians. She expected to find in those histories some adventures similar to her own, which might alleviate her grief. The maid of honor read, the phœnix made comments, and the princess,

finding nothing in the "Fortunate Country Maid," in "Tansai," or in the "Sopha," that had the least resemblance to her own affairs, interrupted the reader every moment by asking how the wind stood.

CHAPTER VIII.

AMAZAN LEAVES ALBION TO VISIT THE LAND OF SATURN.

In the meantime Amazan was on the road to the capital of Albion in his coach and six unicorns, all his thoughts employed on his dear princess. At a small distance he perceived a carriage overturned in a ditch. The servants had gone in different directions in quest of assistance, but the owner kept his seat, smoking his pipe with great tranquillity, without manifesting the smallest impatience. His name was my lord What-then, in the language from which I translate these memoirs.

Amazan made all the haste possible to help him, and without assistance set the carriage to rights, so much was his strength superior to that of other men. My lord What-then took no other notice of him than saying, "A stout fellow, by Jove!" In the meantime the neighboring people, having arrived, flew into a great passion at being called out to no purpose, and fell upon the stranger. They abused him, called him an outlandish dog, and challenged him to strip and box.

Amazan seized a brace of them in each hand and threw them twenty paces from him; the rest, seeing this, pulled off their hats, and bowing with great respect, asked his honor for something to drink. His honor gave them more money than they had ever seen in their lives before. My lord What-then now expressed great esteem for him, and asked him to dinner at his country house, about three miles off. His invitation being accepted, he went into Amazan's coach, his own being out of order from the accident.

After a quarter of an hour's silence, my lord What-then, looking upon Amazan for a moment, said: "How d'ye do?" which, by the way, is a phrase without any meaning; adding, "You have got six fine unicorns there." After which he continued smoking as usual.

The traveller told him his unicorns were at his service, and that he had brought them from the country of the Gangarids. Then he took occasion to inform him of his affair with the princess of Babylon, and the unlucky kiss she had given the king of Egypt; to which the other made no reply, being very indifferent whether there were any such people in the world as a king of Egypt or a princess of Babylon.

He remained dumb for another quarter of an hour, after which he asked his companion a second time how he did, and whether they had any good roast beef among the Gangarids.

Amazan answered with his wonted politeness

that they did not eat their brethren on the banks of the Ganges. He then explained to him that system which many ages afterward was surnamed the Pythagorean philosophy. But my lord fell asleep in the meantime, and made but one nap of it till he came to his own house.

He was married to a young and charming woman, on whom nature had bestowed a soul as lively and sensible as that of her husband was dull and stupid. A few gentlemen of Albion had that day come to dine with her, among whom there were characters of all sorts; for that country having been almost always under the government of foreigners, the families that had come over with these princes had imported their different manners. There were in this company some persons of an amiable disposition, others of superior genius, and a few of profound learning.

The mistress of the house had none of that awkward stiffness, that false modesty, with which the young ladies of Albion were then reproached. She did not conceal by a scornful look and an affected taciturnity her deficiency of ideas and the embarrassing humility of having nothing to say. Never was a woman more engaging. She received Amazan with a grace and politeness that were quite natural to her. The extreme beauty of this young stranger, and the involuntary comparison she could not help making between him and her prosaic husband, did not increase her happiness or content.

Dinner being served, she placed Amazan at her

side, and helped him to a variety of puddings, he having informed her that the Gangarids never dined upon anything which had received from the gods the celestial gift of life. The events of his early life, the manners of the Gangarids, the progress of arts, religion, and government were the subjects of a conversation equally agreeable and instructive all the time of the entertainment, which lasted till night, during which my lord What-then did nothing but push the bottle about, and call for the toast.

After dinner, while my lady was pouring out the tea, still feeding her eyes on the young stranger, he entered into a long conversation with a member of parliament; for every one knows that there was even then a parliament called "Wittenagemot," or the assembly of wise men. Amazan inquired into the constitution, laws, manners, customs, forces, and arts which made this country so respectable; and the member answered him in the following manner:

"For a long time we went stark naked, though our climate is none of the hottest. We were likewise for a long time enslaved by a people who came from the ancient country of Saturn, watered by the Tiber. But the mischief we have done one another has greatly exceeded all that we ever suffered from our first conquerors. One of our princes carried his superstition to such a pitch as to declare himself the subject of a priest, who dwells also on the banks of the Tiber, and is called the Old Man of the Seven Mountains. It has been the fate of the seven moun-

tains to domineer over the greatest part of Europe, then inhabited by brutes in human shape.

"To those times of infamy and debasement succeeded the ages of barbarity and confusion. Our country, more tempestuous than the surrounding ocean, has been ravaged and drenched in blood by our civil discords. Many of our crowned heads have perished by a violent death. Above a hundred princes of the royal blood have ended their days on the scaffold, whilst the hearts of their adherents have been torn from their breasts and thrown in their faces. In short, it is the province of the hangman to write the history of our island, seeing that this personage has finally determined all our affairs of moment.

"But to crown these horrors, it is not very long since some fellows wearing black mantles, and others who cast white shirts over their jackets, having become aggressive and intolerant, succeeded in communicating their madness to the whole nation. Our country was then divided into two parties, the murderers and the murdered, the executioners and the sufferers, plunderers and slaves; and all in the name of God, and while they were seeking the Lord.

"Who would have imagined that from this horrible abyss, this chaos of dissension, cruelty, ignorance, and fanaticism, a government should at last spring up, the most perfect, it may be said, now in the world? yet such has been the event. A prince, honored and wealthy, all-powerful to do good, but

without power to do evil, is at the head of a free, warlike, commercial and enlightened nation. The nobles on one hand and the representatives of the people on the other, share the legislature with the monarch.

"We have seen, by a singular fatality of events, disorder, civil wars, anarchy and wretchedness lay waste the country, when our kings aimed at arbitrary power: whereas tranquillity, riches, and universal happiness have only reigned among us when the prince has remained satisfied with a limited authority. All order had been subverted while we were disputing about mysteries, but was re-established the moment we grew wise enough to despise them. Our victorious fleets carry our flag on every ocean; our laws place our lives and fortunes in security; no judge can explain them in an arbitrary manner, and no decision is ever given without the reasons assigned for it. We should punish a judge as an assassin who should condemn a citizen to death without declaring the evidence which accused him, and the law upon which he was convicted.

"It is true, there are always two parties among us who are continually writing and intriguing against each other; but they constantly reunite whenever it is needful to arm in defence of liberty and our country. These two parties watch over each other, and mutually prevent the violation of the sacred *deposit* of the laws. They hate one another, but they

love the state. They are like those jealous lovers who pay court to the same mistress with a spirit of emulation.

"From the same fund of genius by which we discovered and supported the natural rights of mankind, we have carried the sciences to the highest pitch to which they can attain among men. Your Egyptians, who pass for such great mechanics; your Indians, who are believed to be such great philosophers; your Babylonians, who boast of having observed the stars for the course of four hundred and thirty thousand years; the Greeks, who have written so much, and said so little, know in reality nothing in comparison to our inferior scholars, who have studied the discoveries of our great masters. We have ravished more secrets from nature in the space of a hundred years than the human species had been able to discover in as many ages.

"This is a true account of our present state. I have concealed from you neither the good nor the bad; neither our shame nor our glory; and I have exaggerated nothing."

At this discourse Amazan felt a strong desire to be instructed in those sublime sciences his friend had spoken of; and if his passion for the princess of Babylon, his filial duty to his mother whom he had quitted, and his love for his native country, had not made strong remonstrances to his distempered heart, he would willingly have spent the remainder of his

life in Albion. But that unfortunate kiss his princess
had given the king of Egypt did not leave his mind
at sufficient ease to study the abstruse sciences.

"I confess," said he, "having made a solemn vow
to roam about the world, and to escape from my-
self. I have a curiosity to see that ancient land of
Saturn—that people of the Tiber and of the Seven
Mountains, who have been heretofore your masters.
They must undoubtedly be the first people on earth."

"I advise you by all means," answered the mem-
ber, "to take that journey, if you have the smallest
taste for music or painting. Even we ourselves fre-
quently carry our spleen and melancholy to the Seven
Mountains. But you will be greatly surprised when
you see the descendants of our conquerors."

This was a long conversation, and Amazan had
spoken in so agreeable a manner, his voice was
so charming, his whole behavior so noble and en-
gaging, that the mistress of the house could not re-
sist the pleasure of having a little private chat with
him in her turn. She accordingly sent him a little
billet-doux intimating her wishes in the most agree-
able language. Amazan had once more the courage
to resist the fascination of female society, and ac-
cording to custom, wrote the lady an answer full of
respect, representing to her the sacredness of his
oath and the strict obligation he was under to teach
the princess of Babylon to conquer her passion by
his example, after which he harnessed his unicorns
and departed for Batavia, leaving all the company

in deep admiration of him, and the lady in profound astonishment. In her confusion she dropped Amazan's letter. My Lord What-then read it next morning.

"D—n it," said he, shrugging up his shoulders, "what stuff and nonsense have we got here?" and then rode out fox-hunting with some of his drunken neighbors.

Amazan was already sailing upon the sea, possessed of a geographical chart, with which he had been presented by the learned Albion he had conversed with at Lord What-then's. He was extremely astonished to find the greatest part of the earth upon a single sheet of paper.

His eyes and imagination wandered over this little space. He observed the Rhine, the Danube, the Alps of Tyrol, there specified under their different names, and all the countries through which he was to pass before he arrived at the city of the Seven Mountains. But he more particularly fixed his eyes upon the country of the Gangarids, upon Babylon, where he had seen his dear princess, and upon the country of Bassora, where she had given a fatal kiss to the king of Egypt. He sighed, and tears streamed from his eyes at the unhappy remembrance. He agreed with the Albion who had presented him with the universe in epitome, when he averred that the inhabitants of the banks of the Thames were a thousand times better instructed than those upon the banks of the Nile, the Euphrates, and the Ganges.

As he returned into Batavia, Formosanta proceeded toward Albion with her two ships at full sail. Amazan's ship and the princess' crossed one another and almost touched; the two lovers were close to each other without being conscious of the fact. Ah! had they but known it! But this great consolation tyrannic destiny would not allow.

CHAPTER IX.

AMAZAN VISITS ROME.

No sooner had Amazan landed on the flat, muddy shore of Batavia, than he immediately set out toward the city of the Seven Mountains. He was obliged to traverse the southern part of Germany. At every four miles he met with a prince and princess, maids of honor, and beggars. He was greatly astonished everywhere at the coquetries of these ladies and maids of honor, in which they indulged with German good faith. After having cleared the Alps he embarked upon the sea of Dalmatia and landed in a city that had no resemblance to anything he had heretofore seen. The sea formed the streets, and the houses were erected in the water. The few public places with which this city was ornamented were filled with men and women with double faces—that which nature had bestowed on them, and a pasteboard one, ill painted, with which they covered their

natural visage; so that this people seemed composed of spectres. Upon the arrival of strangers in this country they immediately purchase these visages in the same manner as people elsewhere furnish themselves with hats and shoes. Amazan despised a fashion so contrary to nature. He appeared just as he was.

Many ladies were introduced and interested themselves in the handsome Amazan. But he fled with the utmost precipitancy, uttering the name of the incomparable princess of Babylon and swearing by the immortal gods that she was far handsomer than the Venetian girls.

"Sublime traitoress," he cried in his transports, "I will teach you to be faithful!"

Now the yellow surges of the Tiber, pestiferous fens, a few pale, emaciated inhabitants clothed in tatters which displayed their dry, tanned hides, appeared to his sight and bespoke his arrival at the gate of the city of the Seven Mountains—that city of heroes and legislators who conquered and polished a great part of the globe.

He expected to have seen at the triumphal gate five hundred battalions commanded by heroes, and in the senate an assembly of demi-gods giving laws to the earth. But the only army he found consisted of about thirty tatterdemalions mounting guard with umbrellas for fear of the sun. Having arrived at a temple which appeared to him very fine, but not so

magnificent as that of Babylon, he was greatly as-
tonished to hear a concert performed by men with
female voices.

"This," said he, "is a mighty pleasant country,
which was formerly the land of Saturn. I have been
in a city where no one showed his own face; here is
another where men have neither their own voices nor
beards."

He was told that these eunuchs had been trained
from childhood, that they might sing the more agree-
ably the praises of a great number of persons of merit.
Amazan could not comprehend the meaning of this.

They then explained to him very pleasantly and
with many gesticulations, according to the custom
of their country, the point in question. Amazan was
quite confounded.

"I have travelled a great way," said he, "but I
never before heard such a whim."

After they had sung a good while the Old Man of
the Seven Mountains went with great ceremony to
the gate of the temple. He cut the air in four parts
with his thumb raised, two fingers extended and
two bent, in uttering these words in a language
no longer spoken: *To the city and to the universe.*
Amazan could not see how two fingers could extend
so far.

He presently saw the whole court of the master of
the world file off. This court consisted of grave per-
sonages, some in scarlet and others in violet robes.
They almost all eyed the handsome Amazan with a

tender look, and bowed to him, while commenting upon his personal appearance.

The zealots whose vocation was to show the curiosities of the city to strangers very eagerly offered to conduct him to several ruins, in which a muleteer would not choose to pass a night, but which were formerly worthy monuments of the grandeur of a royal people. He moreover saw pictures of two hundred years' standing, and statues that had remained twenty ages, which appeared to him masterpieces of their kind.

"Can you still produce such work?" said Amazan.

"No, your excellency," replied one of the zealots; "but we despise the rest of the earth because we preserve these rarities. We are a kind of old-clothes men, who derive our glory from the cast-off garbs in our warehouses."

Amazan was willing to see the prince's palace and he was accordingly conducted thither. He saw men dressed in violet-colored robes, who were reckoning the money of the revenues of the domains of lands, some situated upon the Danube, some upon the Loire, others upon the Guadalquivir, or the Vistula.

"Oh! Oh!" said Amazan, having consulted his geographical map, "your master, then, possesses all Europe, like those ancient heroes of the Seven Mountains?"

"He should possess the whole universe by divine right," replied a violet-livery man; "and there was even a time when his predecessors nearly compassed

universal monarchy, but their successors are so good as to content themselves at present with some moneys which the kings, their subjects, pay to them in the form of a tribute."

"Your master is then, in fact, the king of kings. Is that his title?" said Amazan.

"No, your excellency, his title is *the servant of servants!* He was originally a fisherman and porter, wherefore the emblems of his dignity consist of keys and nets; but he at present issues orders to every king in Christendom. It is not a long while since he sent one hundred and one mandates to a king of the Celts, and the king obeyed."

"Your fisherman must then have sent five or six hundred thousand men to put these orders in execution?"

"Not at all, your excellency. Our holy master is not rich enough to keep ten thousand soldiers on foot; but he has five or six hundred thousand divine prophets dispersed in other countries. These prophets of various colors are, as they ought to be, supported at the expense of the people where they reside. They proclaim, from heaven, that my master may, with his keys, open and shut all locks, and particularly those of strong boxes. A Norman priest, who held the post of confidant of their king's thoughts, convinced him he ought to obey, without questioning, the one hundred and one thoughts of my master; for you must know that one of the prerogatives of the Old Man of the Seven Mountains is

never to err, whether he deigns to speak or deigns to write."

"In faith," said Amazan, "this is a very singular man; I should be pleased to dine with him."

"Were your excellency even a king, you could not eat at his table. All that he could do for you would be to allow you to have one served by the side of his, but smaller and lower. But if you are inclined to have the honor of speaking to him, I will ask an audience for you on condition of the *buona mancia,* which you will be kind enough to give me."

"Very readily," said the Gangarid. The violet-livery man bowed: "I will introduce you to-morrow," said he. "You must make three very low bows, and you must kiss the feet of the Old Man of the Seven Mountains." At this information Amazan burst into so violent a fit of laughing that he was almost choked; which, however, he surmounted, holding his sides, whilst the violent emotions of the risible muscles forced the tears down his cheeks, till he reached the inn, where the fit still continued upon him.

At dinner twenty beardless men and twenty violins produced a concert. He received the compliments of the greatest lords of the city during the remainder of the day; but from their extravagant actions he was strongly tempted to throw two or three of these violet-colored gentry out of the window. He left with the greatest precipitation this city of the masters of the world, where young men were

treated so whimsically, and where he found himself necessitated to kiss an old man's toe, as if his cheek were at the end of his foot.

CHAPTER X.

AN UNFORTUNATE ADVENTURE IN GAUL.

In all the provinces through which Amazan passed he remained ever faithful to the princess of Babylon, though incessantly enraged at the king of Egypt. This model of constancy at length arrived at the new capital of the Gauls. This city, like many others, had alternately submitted to barbarity, ignorance, folly, and misery. The first name it bore was Dirt and Mire; it then took that of Isis, from the worship of Isis, which had reached even here. Its first senate consisted of a company of watermen. It had long been in bondage and submitted to the ravages of the heroes of the Seven Mountains; and some ages after some other heroic thieves who came from the farther banks of the Rhine had seized upon its little lands.

Time, which changes all things, had formed it into a city, half of which was very noble and very agreeable, the other half somewhat barbarous and ridiculous: this was the emblem of its inhabitants. There were within its walls at least a hundred thou-

sand people, who had no other employment than play and diversion. These idlers were the judges of those arts which the others cultivated. They were ignorant of all that passed at court, though they were only four short miles distant from it; but it seemed to them at least six hundred thousand miles off. Agreeableness in company, gayety and frivolity formed the important and sole considerations of their lives. They were governed like children who are extravagantly supplied with gewgaws to prevent their crying. If the horrors were discussed which two centuries before had laid waste their country, or if those dreadful periods were recalled when one-half of the nation massacred the other for sophisms, they, indeed, said "this was not well done"; then presently they fell to laughing again or singing of catches.

In proportion as the idlers were polished, agreeable and amiable, it was observed that there was a greater and more shocking contrast between them and those who were engaged in business.

Among the latter, or such as pretended so to be, there was a gang of melancholy fanatics, whose absurdity and knavery divided their characters—whose appearance alone diffused misery—and who would have overturned the world had they been able to gain a little credit. But the nation of idlers, by dancing and singing, forced them into obscurity in their caverns, as the warbling birds drive the croaking bats back to their holes and ruins.

A smaller number of those who were occupied were the preservers of ancient barbarous customs, against which nature, terrified, loudly exclaimed. They consulted nothing but their worm-eaten registers. If they there discovered a foolish or horrid custom, they considered it as a sacred law. It was from this vile practice of not daring to think for themselves, but extracting their ideas from the ruins of those times when no one thought at all, that in the metropolis of pleasure there still remained some shocking manners. Hence it was that there was no proportion between crimes and punishments. A thousand deaths were sometimes inflicted upon an innocent victim to make him acknowledge a crime he had not committed.

The extravagances of youth were punished with the same severity as murder or parricide. The idlers screamed loudly at these exhibitions, and the next day thought no more about them, but were buried in the contemplation of some new fashion.

This people saw a whole age elapse, in which the fine arts attained a degree of perfection that far surpassed the most sanguine hopes. Foreigners then repaired thither, as they did to Babylon, to admire the great monuments of architecture, the wonders of gardening, the sublime efforts of sculpture and painting. They were charmed with a species of music that reached the heart without astonishing the ears.

True poetry, that is to say, such as is natural and

harmonious, that which addresses the heart as well as the mind, was unknown to this nation before this happy period. New kinds of eloquence displayed sublime beauties. The theatres in particular re-echoed with masterpieces that no other nation ever approached. In a word, good taste prevailed in every profession to that degree that there were even good writers among the Druids.

So many laurels that had branched even to the skies soon withered in an exhausted soil. There remained but a very small number, whose leaves were of a pale dying verdure. This decay was occasioned by the facility of producing—laziness preventing good productions—and by a satiety of the brilliant and a taste for the whimsical. Vanity protected arts that brought back times of barbarity; and this same vanity, in persecuting persons of real merit, forced them to quit their country. The hornets banished the bees.

There were scarcely any real arts, there was scarcely any real genius. Talent now consisted in reasoning right or wrong upon the merit of the last age. The dauber of a sign-post criticised with an air of sagacity the works of the greatest painters, and the blotters of paper disfigured the works of the greatest writers. Ignorance and bad taste had other daubers in their pay. The same things were repeated in a hundred volumes under different titles. Every work was either a dictionary or a pamphlet. A Druid gazetteer wrote twice a week the obscure

annals of an unknown people possessed with the
devil, and of celestial prodigies operated in garrets
by little beggars of both sexes. Other ex-Druids,
dressed in black, ready to die with rage and hunger,
set forth their complaints in a hundred different
writings, that they were no longer allowed to cheat
mankind—this privilege being conferred on some
goats clad in grey; and some arch-Druids were em-
ployed in printing defamatory libels.

Amazan was quite ignorant of all this, and even
if he had been acquainted with it he would have given
himself very little concern about it, having his head
filled with nothing but the princess of Babylon, the
king of Egypt and the inviolable vow he had made
to despise all female coquetry in whatever country
his despair should drive him.

The gaping, ignorant mob, whose curiosity ex-
ceeds all the bounds of nature and reason, for a long
time thronged about his unicorns. The more sen-
sible women forced open the doors of his hotel to
contemplate his person.

He at first testified some desire of visiting the
court; but some of the idlers, who constituted good
company and casually went thither, informed him
that it was quite out of fashion, that times were
greatly changed, and that all amusements were con-
fined to the city. He was invited that very night to
sup with a lady whose sense and talents had reached
foreign climes, and who had travelled in some coun-
tries through which Amazan had passed. This lady

gave him great pleasure, as well as the society he met
at her house. Here reigned a decent liberty, gayety
without tumult, silence without pedantry, and wit
without asperity. He found that *good company* was
not quite ideal, though the title was frequently
usurped by pretenders. The next day he dined in a
society far less amiable, but much more voluptuous.
The more he was satisfied with the guests the more
they were pleased with him. He found his soul
soften and dissolve, like the aromatics of his country,
which gradually melt in a moderate heat and exhale
in delicious perfumes.

After dinner he was conducted to a place of public
entertainment which was enchanting, but con-
demned, however, by the Druids, because it deprived
them of their auditors, which, therefore, excited their
jealousy. The representation here consisted of
agreeable verses, delightful songs, dances which ex-
pressed the movements of the soul, and perspectives
that charmed the eye in deceiving it. This kind of
pastime, which included so many kinds, was known
only under a foreign name. It was called "an
Opera," which formerly signified in the language of
the Seven Mountains, work, care, occupation, indus-
try, enterprise, business. This exhibition enchanted
him. A female singer, in particular, charmed him
by her melodious voice and the graces that accom-
panied her. This child of genius, after the perform-
ance, was introduced to him by his new friends. He
presented her with a handful of diamonds, for which

she was so grateful that she could not leave him all the rest of the day. He supped with her and her companions, and during the delightful repast he forgot his sobriety and became heated and oblivious with wine. What an instance of human frailty!

The beautiful princess of Babylon arrived at this juncture, with her phœnix, her chambermaid Irla and her two hundred Gangaridian cavaliers mounted on their unicorns. It was a long while before the gates were opened. She immediately asked if the handsomest, the most courageous, the most sensible and the most faithful of men was still in that city. The magistrates readily concluded that she meant Amazan. She was conducted to his hotel. How great was the palpitation of her heart!—the powerful operation of the tender passion. Her whole soul was penetrated with inexpressible joy, to see once more in her lover the model of constancy. Nothing could prevent her entering his chamber; the curtains were open, and she saw the beautiful Amazan asleep and stupefied with drink.

Formosanta expressed her grief with such screams as made the house echo. She swooned into the arms of Irla. As soon as she had recovered her senses she retired from this fatal chamber with grief blended with rage.

"Oh! just heaven; oh, powerful Oromasdes!" cried the beautiful princess of Babylon, bathed in tears. "By whom, and for whom, am I thus be-

trayed? He that could reject for my sake so many princesses, to abandon me for the company of a strolling Gaul! No! I can never survive this affront."

"This is the disposition of all young people," said Irla to her, "from one end of the world to the other. Were they enamored with a beauty descended from heaven they would at certain moments forget her entirely."

"It is done," said the princess, "I will never see him again while I live. Let us depart this instant and let the unicorns be harnessed."

The phœnix conjured her to stay at least till Amazan awoke, that he might speak with him.

"He does not deserve it," said the princess. "You would cruelly offend me. He would think that I had desired you to reproach him, and that I am willing to be reconciled to him. If you love me do not add this injury to the insult he has offered me."

The phœnix, who after all owed his life to the daughter of the king of Babylon, could not disobey her. She set out with all her attendants.

"Whither are you going?" said Irla to her.

"I do not know," replied the princess; "we will take the first road we find. Provided I fly from Amazan forever I am satisfied."

The phœnix, who was wiser than Formosanta, because he was divested of passion, consoled her upon the road. He gently insinuated to her that it was shocking to punish one's self for the faults of an-

other; that Amazan had given proofs sufficiently striking and numerous of his fidelity, so that she should forgive him for having forgotten himself for one moment in social company; that this was the only time in which he had been wanting of the grace of Oromasdes; that it would render him only the more constant in love and virtue for the future; that the desire of expiating his fault would raise him beyond himself; that it would be the means of increasing her happiness; that many great princesses before her had forgiven such slips and had had no reason to be sorry afterwards; and he was so thoroughly possessed of the art of persuasion, that Formosanta's mind grew more calm and peaceable. She was now sorry she had set out so soon. She thought her unicorns went too fast, but she did not dare return. Great was the conflict between her desire of forgiving and that of showing her rage—between her love and vanity. However, her unicorns pursued their pace, and she traversed the world according to the prediction of her father's oracle.

When Amazan awoke, he was informed of the arrival and departure of Formosanta and the phœnix. He was also told of the rage and distraction of the princess, and that she had sworn never to forgive him.

"Then," said he, "there is nothing left for me to do but follow her and kill myself at her feet."

The report of this adventure drew together his festive companions, who all remonstrated with him.

They said that he had much better stay with them; that nothing could equal the pleasant life they led in the centre of arts and refined delicate pleasures; that many strangers, and even kings, preferred such an agreeable, enchanting repose to their country and their thrones. Moreover, his vehicle was broken, and another was being made for him according to the newest fashion; that the best tailor of the whole city had already cut out for him a dozen suits in the latest style; that the most vivacious, amiable and fashionable ladies, at whose houses dramatic performances were represented, had each appointed a day to give him a regale. The girl from the opera was in the meanwhile drinking her chocolate, laughing, singing and ogling the beautiful Amazan, who by this time clearly perceived she had no more sense than a goose.

A sincerity, cordiality and frankness, as well as magnanimity and courage, constituted the character of this great prince; he related his travels and misfortunes to his friends. They knew that he was cousin-german to the princess. They were informed of the fatal kiss she had given the king of Egypt. "Such little tricks," said they, "are often forgiven between relatives, otherwise one's whole life would pass in perpetual uneasiness."

Nothing could shake his design of pursuing Formosanta; but his carriage not being ready, he was compelled to remain three days longer among the idlers, who were still feasting and merry-making.

He at length took his leave of them by embracing them and making them accept some of his diamonds that were the best mounted, and recommending to them a constant pursuit of frivolity and pleasure, since they were thereby made more agreeable and happy.

"The Germans," said he, "are the greyheads of Europe; the people of Albion are men formed; the inhabitants of Gaul are the children—and I love to play with children."

CHAPTER XI.

AMAZAN AND FORMOSANTA BECOME RECONCILED.

The guides had no difficulty in following the route the princess had taken. There was nothing else talked of but her and her large bird. All the inhabitants were still in a state of fascination. The banks of the Loire, of the Dordogne, the Garonne, and the Gironde still echoed with acclamation.

When Amazan reached the foot of the Pyrenees, the magistrates and druids of the country made him dance, whether he would or not, a *tambourin;* but as soon as he cleared the Pyrenees, nothing presented itself that was either gay or joyous. If he here and there heard a peasant sing, it was a doleful ditty. The inhabitants stalked with much gravity, having a few strung beads and a girted poniard. The nation dressed in black, and appeared to be in mourning.

If Amazan's servants asked passengers any questions, they were answered by signs; if they went into an inn the host acquainted his guests in three words that there was nothing in the house, but that the things they so pressingly wanted might be found a few miles off.

When these votaries to taciturnity were asked if they had seen the beautiful princess of Babylon pass, they answered with less brevity than usual: "We have seen her—she is not so handsome—there are no beauties that are not tawny—she displays a bosom of alabaster, which is the most disgusting thing in the world, and which is scarce known in our climate."

Amazan advanced toward the province watered by the Betis. The Tyrians discovered this country about twelve thousand years ago, about the time they discovered the great Atlantic isle, inundated so many centuries after. The Tyrians cultivated Betica, which the natives of the country had never done, being of opinion that it was not their place to meddle with anything, and that their neighbors, the Gauls, should come and reap their harvests. The Tyrians had brought with them some Palestines, or Jews, who, from that time, have wandered through every clime where money was to be gained. The Palestines, by extraordinary usury, at fifty per cent, had possessed themselves of almost all the riches of the country. This made the people of Betica imagine the Palestines were sorcerers; and all those who

were accused of witchcraft were burned, without mercy, by a company of druids, who were called the inquisitors, or the *anthropokaies*. These priests immediately put their victims in a masquerade habit, seized upon their effects, and devoutly repeated the Palestines' own prayers, while burning them by a slow fire, *por el amor de Dios*.

The princess of Babylon alighted in that city which has since been called Sevilla. Her design was to embark upon the Betis to return by Tyre to Babylon, and see again King Belus, her father; and forget, if possible, her perfidious lover—or, at least, to ask him in marriage. She sent for two Palestines, who transacted all the business of the court. They were to furnish her with three ships. The phœnix made all the necessary contracts with them, and settled the price after some little dispute.

The hostess was a great devotee, and her husband, who was no less religious, was a Familiar; that is to say, a spy of the druid inquisitors, or *anthropokaies*.

He failed not to inform them that in his house was a sorceress and two Palestines, who were entering in a compact with the devil, disguised like a large gilt bird.

The inquisitors having learned that the lady possessed a large quantity of diamonds, swore point blank that she was a sorceress. They waited till night to imprison the two hundred cavaliers and the

unicorns, which slept in very extensive stables, for the inquisitors are cowards.

Having strongly barricaded the gates, they seized the princess and Irla; but they could not catch the phœnix, who flew away with great swiftness. He did not doubt of meeting the Amazan upon the road from Gaul to Sevilla.

He met him upon the frontiers of Betica, and acquainted him with the disaster that had befallen the princess.

Amazan was struck speechless with rage. He armed himself with a steel cuirass damaskeened with gold, a lance twelve feet long, two javelins, and an edged sword called the Thunderer, which at one single stroke would rend trees, rocks and druids. He covered his beautiful head with a golden casque, shaded with heron and ostrich feathers. This was the ancient armor of Magog, which his sister Aldea gave him when upon his journey in Scythia. The few attendants he had with him all mounted their unicorns.

Amazan, in embracing his dear phœnix, uttered only these melancholy expressions: "I am guilty! Had I not dined with the child of genius from the opera, in the city of the idlers, the princess of Babylon would not have been in this alarming situation. Let us fly to the *anthropokaies*." He presently entered Sevilla. Fifteen hundred alguazils guarded the gates of the enclosure in which the two hundred

Gangarids and their unicorns were shut up, without being allowed anything to eat. Preparations were already made for sacrificing the princess of Babylon, her chambermaid Irla, and the two rich Palestines.

The high *anthropokaie,* surrounded by his subaltern *anthropokaies,* was already seated upon his sacred tribunal. A crowd of Sevillians, wearing strung beads at their girdles, joined their two hands, without uttering a syllable, when the beautiful princess, the maid Irla, and the two Palestines were brought forth, with their hands tied behind their backs and dressed in masquerade habits.

The phœnix entered the prison by a dormer window, while the Gangarids began to break open the doors. The invincible Amazan shattered them without. They all sallied forth, armed, upon their unicorns, and Amazan put himself at their head. He had no difficulty in overthrowing the alguazils, the familiars, or the priests called *anthropokaies.* Each unicorn pierced dozens at a time. The thundering Amazan cut to pieces all he met. The people in black cloaks and dirty frieze ran away, always keeping fast hold of their blessed beads, *por el amor de Dios.*

Amazan collared the high inquisitor upon his tribunal and threw him upon the pile, which was prepared about forty paces distant; and he also cast upon it the other inquisitors, one after the other. He then prostrated himself at Formosanta's feet. "Ah! how amiable you are," said she; "and how I should

adore you if you had not forsaken me for the company of an opera singer."

While Amazan was making his peace with the princess, while his Gangarids cast upon the pile the bodies of all the *anthropokaies,* and the flames ascended to the clouds, Amazan saw an army that approached him at a distance. An aged monarch, with a crown upon his head, advanced upon a car drawn by eight mules harnessed with ropes. A hundred other cars followed. They were accompanied by grave-looking men in black coats of frieze, mounted upon very fine horses. A multitude of people, with greasy hair, followed silently on foot.

Amazan immediately drew up his Gangarids about him, and advanced with his lance couched. As soon as the king perceived him, he took off his crown, alighted from his car, and embraced Amazan's stirrup, saying to him: "Man sent by the gods, you are the avenger of human kind, the deliverer of my country. These sacred monsters, of which you have purged the earth, were my masters, in the name of the Old Man of the Seven Mountains. I was forced to submit to their criminal power. My people would have deserted me if I had only been inclined to moderate their abominable crimes. From this moment I breathe, I reign, and am indebted to you for it."

He afterwards respectfully kissed Formosanta's hand, and entreated her to get into his coach (drawn by eight mules) with Amazan, Irla, and the phœnix.

The two Palestine bankers, who still remained prostrate on the ground through fear and terror, now raised their heads. The troop of unicorns followed the king of Betica into his palace.

As the dignity of a king who reigned over a people of characteristic brevity required that his mules should go at a very slow pace, Amazan and Formosanta had time to relate to him their adventures. He also conversed with the phœnix, admiring and frequently embracing him. He easily comprehended how brutal and barbarous the people of the West should be considered, who ate animals and did not understand their language; that the Gangarids alone had preserved the nature and dignity of primitive man; but he particularly agreed that the most barbarous of mortals were the *anthropokaies,* of whom Amazan had just purged the earth. He incessantly blessed and thanked him. The beautiful Formosanta had already forgotten the affair in Gaul, and had her soul filled with nothing but the valor of the hero who had preserved her life. Amazan being made acquainted with the innocence of the embrace she had given to the king of Egypt, and being told of the resurrection of the phœnix, tasted the purest joy, and was intoxicated with the most violent love.

They dined at the palace, but had a very indifferent repast. The cooks of Betica were the worst in Europe. Amazan advised the king to send for some from Gaul. The king's musicians performed, during the repast, that celebrated air which has since been

called "The Follies of Spain." After dinner matters of business came upon the carpet.

The king inquired of the handsome Amazan, the beautiful Formosanta, and the charming phœnix, what they proposed doing. "For my part," said Amazan, "my intention is to return to Babylon, of which I am the presumptive heir, and to ask of my uncle Belus the hand of my cousin-german, the incomparable Formosanta."

"My design certainly is," said the princess, "never to separate from my cousin-german. But I imagine he will agree with me that I should return first to my father, because he only gave me leave to go upon a pilgrimage to Bassora, and I have wandered all over the world."

"For my part," said the phœnix, "I will follow everywhere these two tender, generous lovers."

"You are in the right," said the king of Betica; "but your return to Babylon is not so easy as you imagine. I receive daily intelligence from that country by Tyrian ships, and my Palestine bankers, who correspond with all the nations of the earth. The people are all in arms towards the Euphrates and the Nile. The king of Scythia claims the inheritance of his wife, at the head of three hundred thousand warriors on horseback. The kings of Egypt and India are also laying waste the banks of the Tigris and the Euphrates, each at the head of three thousand men, to revenge themselves for being laughed at. The king of Ethiopia is ravaging Egypt with three hun-

dred thousand men while the king of Egypt is absent from his country. And the king of Babylon has as yet only six hundred thousand men to defend himself.

"I acknowledge to you," continued the king, "when I hear of those prodigious armies which are disembogued from the East, and their astonishing magnificence; when I compare them to my trifling bodies of twenty or thirty thousand soldiers, which it is so difficult to clothe and feed, I am inclined to think the eastern existed long before the western hemisphere. It seems as if we sprung only yesterday from chaos and barbarity."

"Sire," said Amazan, "the last comers frequently outstrip those who first began the career. It is thought in my country that man was first created in India; but of this I am not certain."

"And," said the king of Betica to the phœnix, "what do you think?"

"Sire," replied the phœnix, "I am as yet too young to have any knowledge concerning antiquity. I have lived only about twenty-seven thousand years; but my father, who had lived five times that age, told me he had learned from his father that the eastern country had always been more populous and rich than the others. It had been transmitted to him from his ancestors that the generation of all animals had begun upon the banks of the Ganges. For my part," said he, "I have not the vanity to be of this opinion. I cannot believe that the foxes of Albion,

the marmots of the Alps and the wolves of Gaul are descended from my country. In the like manner I do not believe that the firs and oaks of your country descended from the palm and cocoa trees of India."

"But whence are we descended, then?" said the king.

"I do not know," said the phœnix; "all I want to know is, whither the beautiful princess of Babylon and my dear Amazan may repair?"

"I very much question," said the king, "whether with his two hundred unicorns he will be able to destroy so many armies of three hundred thousand men each."

"Why not?" said Amazan.

The king of Betica felt the force of this sublime question, "Why not?" but he imagined sublimity alone was not sufficient against innumerable armies.

"I advise you," said he, "to seek the king of Ethiopia. I am related to that black prince through my Palestines. I will give you letters of recommendation to him. As he is at enmity with the king of Egypt, he will be but too happy to be strengthened by your alliance. I can assist you with two thousand sober, brave men; and it will depend upon yourself to engage as many more of the people who reside, or rather skip, about the foot of the Pyrenees, and who are called Vasques or Vascons. Send one of your warriors upon a unicorn, with a few diamonds. There is not a Vascon that will not quit the castle, that is the thatched cottage of his father, to serve

you. They are indefatigable, courageous, and agreeable; and while you wait their arrival, we will give you festivals, and prepare your ships. I cannot too much acknowledge the service you have done me."

Amazan realized the happiness of having recovered Formosanta, and enjoyed in tranquillity her conversation, and all the charms of reconciled love, which are almost equal to a growing passion.

A troop of proud, joyous Vascons soon arrived, dancing a *tambourin*. The haughty and grave Betican troops were now ready. The old sunburned king tenderly embraced the two lovers. He sent great quantities of arms, beds, chests, boards, black clothes, onions, sheep, fowls, flour, and particularly garlic, cn board the ships, and wished them a happy voyage, invariable love, and many victories.

Proud Carthage was not then a seaport. There were at that time only a few Numidians there, who dried fish in the sun. They coasted along Bizacenes, the Syrthes, the fertile banks where since arose Cyrene and the great Chersonese.

They at length arrived towards the first mouth of the sacred Nile. It was at the extremity of this fertile land that the ships of all commercial nations were already received in the port of Canope, without knowing whether the god Canope had founded this port, or whether the inhabitants had manufactured the god—whether the star Canope had given its name to the city, or whether the city had bestowed it upon the star. All that was known of this matter

was that the city and the star were both very ancient; and this is all that can be known of the origin of things, of whatsoever nature they may be.

It was here that the king of Ethiopia, having ravaged all Egypt, saw the invincible Amazan and the adorable Formosanta come on shore. He took one for the god of war, and the other for the goddess of beauty. Amazan presented to him the letter of recommendation from the king of Spain. The king of Ethiopia immediately entertained them with some admirable festivals, according to the indispensable custom of heroic times. They then conferred about their expedition to exterminate the three hundred thousand men of the king of Egypt, the three hundred thousand of the emperor of the Indies, and the three hundred thousand of the great khan of the Scythians, who laid siege to the immense, proud, voluptuous city of Babylon.

The two hundred Spaniards whom Amazan had brought with him said that they had nothing to do with the king of Ethiopia's succoring Babylon; that it was sufficient their king had ordered them to go and deliver it; and that they were formidable enough for this expedition.

The Vascons said they had performed many other exploits; that they would alone defeat the Egyptians, the Indians, and the Scythians; and that they would not march unless the Spaniards were placed in the rear-guard.

The two hundred Gangarids could not refrain

from laughing at the pretensions of their allies, and they maintained that with only one hundred unicorns, they could put to flight all the kings of the earth. The beautiful Formosanta appeased them by her prudence, and by enchanting discourse. Amazan introduced to the black monarch his Gangarids, his unicorns, his Spaniards, his Vascons, and his beautiful bird.

Everything was soon ready to march by Memphis, Heliopolis, Arsinoë, Petra, Artemitis, Sora, and Apamens, to attack the three kings, and to prosecute this memorable war, before which all the wars ever waged by man sink into insignificance.

Fame with her hundred tongues has proclaimed the victories Amazan gained over the three kings, with his Spaniards, his Vascons, and his unicorns. He restored the beautiful Formosanta to her father. He set at liberty all his mistress' train, whom the king of Egypt had reduced to slavery. The great khan of the Scythians declared himself his vassal; and his marriage was confirmed with Princess Aldea. The invincible and generous Amazan was acknowledged the heir to the kingdom of Babylon, and entered the city in triumph with the phœnix, in the presence of a hundred tributary kings. The festival of his marriage far surpassed that which King Belus had given. The bull Apis was served up roasted at table. The kings of Egypt and India were cupbearers to the married pair, and the nuptials were celebrated by five hundred illustrious poets of Babylon.

Oh, Muses! daughters of heaven, who are constantly invoked at the beginning of a work, I only implore you at the end. It is needless to reproach me with saying grace, without having said *benedicite*. But, Muses! you will not be less my patronesses. Inspire, I pray you, the "Ecclesiastical Gazetteer," the illustrious orator of the *"Convulsionnaires,"* to say everything possible against "The Princess of Babylon," in order that the work may be condemned by the Sorbonne, and, therefore, be universally read. And prevent, I beseech you, O chaste and noble Muses, any supplemental scribblers spoiling, by their fables, the truths I have taught mortals in this faithful narrative.

THE BLACK AND THE WHITE.

The adventure of the youthful Rustan is generally known throughout the whole province of Candahar. He was the only son of a mirza of that country. The title of mirza there is much the same as that of marquis among us, or that of baron among the Germans. The mirza, his father, had a handsome fortune. Young Rustan was to be married to a mirzasse, or young lady of his own rank. The two families earnestly desired their union. Rustan was to become the comfort of his parents, to make his wife happy, and to live blessed in her possession.

But he had unfortunately seen the princess of Cachemir at the fair of Cabul, which is the most considerable fair in the world, and much more frequented than those of Bassora and Astracan. The occasion that brought the old prince of Cachemir to the fair with his daughter was as follows:

He had lost the two most precious curiosities of his treasury; one of them was a diamond as thick as a man's thumb, upon which the figure of his daughter was engraved by an art which was then possessed by the Indians, and has since been lost; the other was a javelin, which went of itself wherever its owner thought proper to send it. This is nothing very ex-

traordinary among us, but it was thought so at Cachemir.

A fakir belonging to his highness stole these two curiosities; he carried them to the princess.

"Keep these two curiosities with the utmost care; your destiny depends upon them," said he, and then departed.

The duke of Cachemir, in despair, resolved to visit the fair of Cabul, in order to see whether there might not, among the merchants who go thither from all quarters of the world, be some one possessed of his diamond and his weapon. The princess carried his diamond well fastened to her girdle; but the javelin, which she could not so easily hide, she had carefully locked up at Cachemir in a large chest.

Rustan and she saw each other at Cabul. They loved one another with all the sincerity of persons of their age, and all the tenderness of affection natural to those of their country. The princess gave Rustan her diamond as a pledge of her love, and he promised at his departure to go incognito to Cachemir, in order to pay her a visit.

The young mirza had two favorites, who served him as secretaries, grooms, stewards, and valets de chambre. The name of one was Topaz; he was handsome, well-shaped, fair as a Circassian beauty, as mild and ready to serve as an Armenian, and as wise as a Gueber. The name of the other was Ebene; he was a very beautiful negro, more active and industrious than Topaz, and one that thought nothing

difficult. The young mirza communicated his intention of travelling to these. Topaz endeavored to dissuade him from it, with the circumspect zeal of a servant who was unwilling to offend him. He represented to him the great danger to which he exposed himself. He asked him how he could leave two families in despair? how he could pierce the hearts of his parents? He shook the resolution of Rustan; but Ebene confirmed it anew, and obviated all his objections.

The young man was not furnished with money to defray the charge of so long a voyage. The prudent Topaz would not have lent him any; Ebene supplied him. He, with great address, stole his master's diamond, made a false one exactly like it, which he put in its place, and pledged the true one to an Armenian for several thousand rupees.

As soon as the marquis possessed these rupees, all things were in readiness for his departure. An elephant was loaded with his baggage. His attendants mounted on horseback.

Topaz said to his master: "I have taken the liberty to expostulate with you upon your enterprise, but after expostulating it is my duty to obey. I am devoted to you, I love you, I will follow you to the extremity of the earth; but let us by the way consult the oracle that is but two parasangs distant from here."

Rustan consented. The answer returned by the oracle was:

"If you go to the east you will be at the west."

Rustan could not guess the meaning of this answer. Topaz maintained that it boded no good. Ebene, always complaisant to his master, persuaded him that it was highly favorable.

There was another oracle at Cabul; they went to it. The oracle of Cabul made answer in these words:

"If you possess, you will cease to possess; if you are conqueror, you will not conquer; if you are Rustan, you will cease to be so."

This oracle seemed still more unintelligible than the former.

"Take care of yourself," said Topaz.

"Fear nothing," said Ebene; and this minister, as may well be imagined, was always thought in the right by his master, whose passions and hopes he encouraged. Having left Cabul, they passed through a vast forest. They seated themselves upon the grass in order to take a repast, and left their horses grazing. The attendants were preparing to unload the elephant which carried the dinner, the table, cloth, plates, etc., when, all on a sudden, Topaz and Ebene were perceived by the little caravan to be missing. They were called, the forest resounded with the names of Topaz and Ebene; the lackeys seek them on every side, and fill the forest with their cries; they return without having seen anything, and without having received any answer.

"We have," said they to Rustan, "found nothing

but a vulture that fought with an eagle, and stripped it of all its feathers."

The mention of this combat excited the curiosity of Rustan; he went on foot to the place; he perceived neither vulture nor eagle; but he saw his elephant, which was still loaded with baggage, attacked by a huge rhinoceros; one struck with its horn, the other with its proboscis. The rhinoceros desisted upon seeing Rustan; his elephant was brought back, but his horses were not to be found.

"Strange things happen in forests to travellers," cried Rustan.

The servants were in great consternation, and the master in despair from having at once lost his horse, his dear negro, and the wise Topaz, for whom he still entertained a friendship, though always differing from him in opinion.

The hope of being soon at the feet of the beautiful princess still consoled the mirza, who, journeying on, now met with a huge streaked ass, which a vigorous two-handed country clown beat with an oaken cudgel. The asses of this sort are extremely beautiful, very scarce, and beyond comparison swift in running. The ass resented the repeated blows of the clown by kicks which might have rooted up an oak. The young mirza, as was reasonable, took upon him the defence of the ass, which was a charming creature. The clown betook himself to flight, crying to the ass, "You shall pay for this."

The ass thanked its deliverer in its own language,

and approaching him, permitted his caresses and caressed him in her turn. After dinner, Rustan mounted it and took the road to Cachemir with his servants, who followed him, some on foot and some upon the elephant. Scarce had he mounted his ass, when that animal turned toward Cabul, instead of proceeding to Cachemir. It was to no purpose for her master to turn the bridle, to kick, to press the sides of the beast with his knees, to spur, to slacken the bridle, to pull toward him, to whip both on the right and the left. The obstinate animal persisted in running toward Cabul.

Rustan in despair fretted and raved, when he met with a dealer in camels, who said to him:

"Master, you have there a very malicious beast, that carries you where you do not choose to go. If you will give it to me, I will give you the choice of four of my camels."

Rustan thanked Providence for having thrown so good a bargain in the way.

"Topaz was very much in the wrong," said he, "to tell me that my journey would prove unprosperous."

He mounts the handsome camel, the others follow; he rejoins his caravan, and fancies himself on the road to happiness.

Scarce had he journeyed four parasangs, when he was stopped by a deep, broad, and impetuous torrent, which rolled over huge rocks white with foam. The two banks were frightful precipices which daz-

zled the sight and made the blood run cold. To pass was impracticable; to go to the right or to the left was impossible.

"I am beginning to be afraid," said Rustan, "that Topaz was in the right in blaming my journey, and that I was in the wrong in undertaking it. If he were still here he might give me good advice. If I had Ebene with me, he would comfort me and find expedients; but everything fails me." This perplexity was increased by the consternation of his attendants. The night was dark, and they passed it in lamentations. At last fatigue and dejection made the amorous traveller fall asleep. He awoke at daybreak, and saw, spanning the torrent, a beautiful marble bridge which reached from shore to shore.

Nothing was heard but exclamations, cries of astonishment and joy. Is it possible? Is this a dream? What a prodigy is this! What an enchantment! Shall we venture to pass? The whole company kneeled, rose up, went to the bridge, kissed the ground, looked up to heaven, stretched out their hands, set their feet on it with trembling, went to and fro, fell into ecstasies, and Rustan said:

"At last heaven favors me. Topaz did not know what he was saying. The oracles were favorable to me. Ebene was in the right, but why is he not here?"

Scarce had the company got beyond the torrent, when the bridge sank into the water with a prodigious noise.

"So much the better, so much the better," cried Rustan. "Praised be God, blessed be heaven; it would not have me return to my country, where I should be nothing more than a gentleman. The intention of heaven is that I should wed her I love. I shall become prince of Cachemir; thus in possessing my mistress I shall cease to possess my little marquisate at Candahar. 'I shall be Rustan, and I shall not be Rustan,' because I shall have become a great prince; thus is a great part of the oracle clearly explained in my favor. The rest will be explained in the same manner. I am very happy. But why is not Ebene with me? I regret him a thousand times more than Topaz."

He proceeded a few parasangs farther with the greatest alacrity imaginable; but, at the close of day, a chain of mountains more rugged than a counterscarp, and higher than the tower of Babel would have been had it been finished, stopped the passage of the caravan, which was again seized with dread.

All the company cried out: "It is the will of God that we perish here! He broke the bridge merely to take from us all hopes of returning; He raised the mountain for no other reason than to deprive us of all means of advancing. Oh, Rustan! oh, unhappy marquis! we shall never see Cachemir; we shall never return to the land of Candahar."

The most poignant anguish, the most insupportable dejection succeeded in the soul of Rustan to the

immoderate joy which he had felt, to the hopes with
which he had intoxicated himself. He was no longer
disposed to interpret the prophecies in his favor.

"Oh, heavens! oh, God of my fathers!" said he,
"must I then lose my friend Topaz!"

As he pronounced these words, heaving deep sighs
and shedding tears in the midst of his disconsolate
followers, the base of the mountain opened, a long
gallery appeared to the dazzled eyes in a vault lighted
with a hundred thousand torches. Rustan imme-
diately begins to exult, and his people to throw them-
selves upon their knees and to fall upon their backs
in astonishment, and cry out, "A miracle! a miracle!
Rustan is the favorite of Witsnow, the well-beloved
of Brahma. He will become the master of man-
kind."

Rustan believed it; he was quite beside himself;
he was raised above himself.

"Alas, Ebene," said he, "my dear Ebene, where
are you? Why are you not witness of all these won-
ders? How did I lose you? Beauteous princess of
Cachemir, when shall I again behold your charms!"

He advances with his attendants, his elephants,
and his camels under the hollow of the mountain, at
the end of which he enters into a meadow enamelled
with flowers and encompassed with rivulets. At the
extremity of the meadows are walks of trees to the
end of which the eye cannot reach, and at the end of
these alleys is a river, on the sides of which are a
thousand pleasure houses with delicious gardens.

He everywhere hears concerts of vocal and instrumental music; he sees dances; he makes haste to go upon one of the bridges of the river; he asks the first man he meets what fine country that is?

He whom he addressed answered:

"You are in the province of Cachemir; you see the inhabitants immersed in joy and pleasure. We celebrate the marriage of our beauteous princess, who is going to be married to the lord Barbabou, to whom her father promised her. May God perpetuate their felicity!"

At these words Rustan fainted away, and the Cachemirian lord thought he was troubled with the falling sickness. He caused him to be carried to his house, where he remained a long time insensible. He sent in search of the two most able physicians in that part of the country. They felt the patient's pulse, who, having somewhat recovered his spirits, sobbed, rolled his eyes, and cried from time to time, "Topaz, Topaz, you were entirely in the right!"

One of the two physicians said to the Cachemirian lord:

"I perceive, by this young man's accent, that he is from Candahar, and that the air of this country is hurtful to him. He must be sent home. I perceive by his eyes that he has lost his senses. Intrust me with him; I will carry him back to his own country and cure him."

The other physician maintained that grief was his only disorder; and that it was proper to carry him to

the wedding of the princess, and make him dance. Whilst they were in consultation, the patient recovered his health. The two physicians were dismissed, and Rustan remained along with his host.

"My lord," said he, "I ask your pardon for having been so free as to faint in your presence. I know it to be a breach of politeness. I entreat you to accept of my elephant, as an acknowledgment of the kindness you have shown me."

He then related to him all his adventure, taking particular care to conceal from him the occasion of his journey.

"But, in the name of Witsnow and Brahma," said he to him, "tell me who is this happy Barbabou who is to marry the princess of Cachemir? Why has her father chosen him for his son-in-law, and why has the princess accepted of him for a husband?"

"Sir," answered the Cachemirian, "the princess has by no means accepted of Barbabou. She is, on the contrary, in tears, whilst the whole province joyfully celebrates her marriage. She has shut herself up in a tower of her palace. She does not choose to see any of the rejoicings made upon the occasion."

Rustan, at hearing this, perceived himself revived. The bloom of his complexion, which grief had caused to fade, appeared again upon his countenance.

"Tell me, I entreat you," continued he, "why the prince of Cachemir is obstinately bent upon giving his daughter to Lord Barbabou, whom she does not love?"

"This is the fact," answered the Cachemirian. "Do you know that our august prince lost a large diamond and a javelin which he considered as of great value?"

"Ah! I very well know that," said Rustan.

"Know then," said his host, "that our prince, being in despair at not having heard of his two precious curiosities after having caused them to be sought for all over the world, promised his daughter to whoever should bring him either the one or the other. A Lord Barbabou came who had the diamond, and he is to marry the princess to-morrow."

Rustan turned pale, stammered out a compliment, took leave of his host, and galloped upon his dromedary to the capital city, where the ceremony was to be performed. He arrives at the palace of the prince, he tells him he has something of importance to communicate to him, he demands an audience. He is told that the prince is taken up with the preparations for the wedding.

"It is for that very reason," said he, "that I am desirous of speaking to him." Such is his importunity, that he is at last admitted.

"Prince," said he, "may God crown all your days with glory and magnificence! Your son-in-law is a knave."

"What! a knave! how dare you speak in such terms? Is that a proper way of speaking to a duke of Cachemir of a son-in-law of whom he has made choice?"

"Yes, he is a knave," continued Rustan, "and to prove it to your highness, I have brought you back your diamond."

The duke, surprised at what he heard, compared the two diamonds; and, as he was no judge of precious stones, he could not determine which was the true one.

"Here are two diamonds," said he, "and I have but one daughter. I am in a strange perplexity."

He sent for Barbabou, and asked him if he had not imposed upon him. Barbabou swore he had bought his diamond from an Armenian; the other did not tell him who he had his from; but he proposed an expedient, which was that he should engage his rival in single combat.

"It is not enough for your son-in-law to give a diamond," said he; "he should also give proofs of valor. Do not you think it just that he who kills his rival should marry the princess?"

"Undoubtedly," answered the prince. "It will be a fine sight for the court. Fight directly. The conqueror shall take the arms of the conquered, according to the customs of Cachemir, and he shall marry my daughter."

The two pretenders to the hand of the princess go down into the court. Upon the stairs there was a jay and a raven. The raven cried, "Fight, fight." The jay cried, "Don't fight."

This made the prince laugh; the two rivals scarce took any notice of it. They begin the combat. All

the courtiers made a circle round them. The princess, who kept herself constantly shut up in her tower, did not choose to behold this sight. She never dreamed that her lover was at Cachemir, and she hated Barbabou to such a degree that she could not bear the sight of him. The combat had the happiest result imaginable. Barbabou was killed outright; and this greatly rejoiced the people, because he was ugly and Rustan was very handsome. The favor of the public is almost always determined by this circumstance.

The conqueror put on the coat of mail, scarf, and the casque of the conquered and came, followed by the whole court, to present himself under the windows of his mistress. The multitude cried aloud: "Beautiful princess, come and see your handsome lover, who has killed his ugly rival." These words were re-echoed by her women. The princess unluckily looked out of the window, and, seeing the armor of a man she hated, she ran like one frantic to her strong box, and took out the fatal javelin, which flew to pierce Rustan, notwithstanding his cuirass. He cried out loudly, and at this cry the princess thought she again knew the voice of her unhappy lover.

She ran downstairs, with her hair dishevelled, and death in her eyes as well as her heart. Rustan had already fallen, all bloody, into the arms of his attendants. She sees him. Oh, moment! oh, sight! oh, discovery of inexpressible grief, tenderness and

horror! She throws herself upon him, and embraces him.

"You receive," said she, "the first and last kisses of your mistress and your murderer."

She pulls the dart from the wound, plunges it in her heart, and dies upon the body of the lover whom she adores. The father, terrified, in despair, and ready to die like his daughter, tries in vain to bring her to life. She was no more. He curses the fatal dart, breaks it to pieces, throws away the two fatal diamonds; and whilst he prepared the funeral of his daughter instead of her marriage, he caused Rustan, who weltered in his blood and had still some remains of life, to be carried to his palace.

He was put into bed. The first objects he saw on each side of his deathbed were Topaz and Ebene. This surprise made him in some degree recover his strength.

"Cruel men," said he, "why did you abandon me? Perhaps the princess would still be alive if you had been with the unhappy Rustan."

"I have not forsaken you a moment," said Topaz.

"I have always been with you," said Ebene.

"Ah! what do you say? Why do you insult me in my last moments?" answered Rustan, with a languishing voice.

"You may believe me," said Topaz. "You know I never approved of this fatal journey, the dreadful consequences of which I foresaw. I was the eagle

that fought with the vulture and stripped it of its feathers; I was the elephant that carried away the baggage, in order to force you to return to your own country; I was the streaked ass that carried you, whether you would or no, to your father; it was I that made your horses go astray; it was I that caused the torrent that prevented your passage; it was I that raised the mountain which stopped up a road so fatal to you; I was the physician that advised you to return to your own country; I was the jay that cried to you not to fight."

"And I," said Ebene, "was the vulture that he stripped of his feathers, the rhinoceros who gave him a hundred strokes with the horn, the clown that beat the streaked ass, the merchant who made you a present of the camels to hasten you to your destruction; I dug the cavern that you crossed, I am the physician that encouraged you to walk, the raven that cried out to you to combat."

"Alas!" said Topaz, "remember the oracles: 'If you go to the east you will be at the west.'"

"Yes," said Ebene, "here the dead are buried with their faces turned to the west. The oracle was plain enough, though you did not understand it. You possessed, and you did not possess; for though you had the diamond, it was a false one, and you did not know it. You are conqueror, and you die; you are Rustan, and you cease to be so; all has been accomplished."

Whilst he spoke thus, four white wings covered the body of Topaz, and four black ones that of Ebene.

"What do I see?" cried Rustan.

Topaz and Ebene answered together: "You see your two genii."

"Good gentlemen," cried the unhappy Rustan, "how came you to meddle; and what occasion had a poor man for two genii?"

"It is a law," answered Topaz; "every man has two genii. Plato was the first man who said so, and others have repeated it after him. You see that nothing can be more true. I who now speak to you am your good genius. I was charged to watch over you to the last moment of your life. Of this task I have faithfully acquitted myself."

"But," said the dying man, "if your business was to serve me, I am of a nature much superior to yours. And then how can you have the assurance to say you are my good genius, since you have suffered me to be deceived in everything I have undertaken, and since you suffer both my mistress and me to die miserably?"

"Alas!" said Topaz, "it was your destiny."

"If destiny does all," answered the dying man, "what is a genius good for? And you, Ebene, with your four black wings, you are doubtless my evil genius."

"You have hit it," answered Ebene.

"Then I suppose you were the evil genius of my princess likewise," said Rustan.

"No," replied Ebene, "she had an evil genius of her own, and I seconded him perfectly."

"Ah! cursed Ebene," said Rustan, "if you are so malicious, you don't belong to the same master with Topaz; you have been formed by two different principles, one of which is by nature good, the other evil."

"That does not follow," said Ebene; "this is a very knotty point."

"It is not possible," answered the dying man, "that a benevolent being could create so destructive a genius."

"Possible or not possible," replied the genius, "the thing is just as I say."

"Alas!" said Topaz, "my poor unfortunate friend, don't you see that that rogue is so malicious as to encourage you to dispute, in order to inflame your blood and hasten your death?"

"Get you gone," said the melancholy Rustan, "I am not much better satisfied with you than with him. He at least acknowledges that it was his intention to hurt me; and you, who pretended to defend me, have done me no service at all."

"I am very sorry for it," said the good genius.

"And I, too," said the dying man; "there is something at the bottom of all this which I cannot comprehend."

"Nor I neither," said the good genius.

"I shall know the truth of the matter in a moment," said Rustan.

"We shall see that," said Topaz.

The whole scene then vanished. Rustan again found himself in the house of his father, which he had not quitted, and in his bed, where he had slept an hour.

He awakes in astonishment, perspiring all over, and quite wild. He rubs himself, he calls, he rings the bell. His valet de chambre, Topaz, runs in, in his nightcap, and yawning.

"Am I dead or alive?" cried out Rustan; "shall the beauteous princess of Cachemir escape?"

"Does your lordship rave?" answered Topaz, coldly.

"Ah!" cried Rustan, "what, then, is become of this barbarous Ebene, with his four black wings! It is he that makes me die by so cruel a death."

"My lord," answered Topaz, "I left him snoring upstairs. Would you have me bid him come down?"

"The villain," said Rustan, "has persecuted me for six months together. It was he who carried me to the fatal fair of Cabul; it is he that cheated me of the diamond which the princess presented me; he is the sole cause of my journey, of the death of my princess, and of the wound with the javelin, of which I die in the flower of my age."

"Take heart," said Topaz; "you were never at Cabul; there is no princess of Cachemir; her father never had any children but two boys, who are now at

college; you never had a diamond; the princess cannot be dead, because she never was born; and you are in perfect health."

"What! is it not then true that you attended me whilst dying, and in the bed of the prince of Cachemir? Did you not acknowledge to me that, in order to preserve me from so many dangers, you were an eagle, an elephant, a streaked ass, a physician, and a jay?"

"My lord, you have dreamed all this," answered Topaz; "our ideas are no more of our own creating whilst we are asleep than whilst we are awake. God has thought proper that this train of ideas should pass in your head, most probably to convey some instruction to you of which you may make a good use."

"You make a jest of me," replied Rustan; "how long have I slept?"

"My lord," said Topaz, "you have not yet slept an hour."

"Cursed reasoner," returned Rustan, "how is it possible that I could be in the space of an hour at the fair of Cabul six months ago; that I could have returned from thence, have travelled to Cachemir, and that Barbabou, the princess, and I should have died?"

"My lord," said Topaz, "nothing can be more easy and more common, and you might have travelled around the world, and have met with a great many more adventures in much less time. Is it not true that you can, in an hour's time, read the abridgment of the Persian history, written by Zoroaster? yet

this abridgment contains eight hundred thousand years. All these events pass before your eyes, one after another, in an hour's time. Now, you must acknowledge that it is as easy to Brahma to confine them to the space of an hour as to extend them to the space of eight hundred thousand years. It is exactly the same thing. Imagine to yourself that time turns upon a wheel whose diameter is infinite. Under this vast wheel is a numerous multitude of wheels one within another. That in the centre is imperceptible, and goes round an infinite number of times, whilst the great wheel performs but one revolution. It is evident that all the events which have happened from the beginning of the world to its end might have happened in much less time than the hundred thousandth part of a second; and one may even go so far as assert that the thing is so."

"I cannot comprehend all this," said Rustan.

"If you want information," said Topaz, "I have a parrot that will easily explain it to you. He was born some time before the deluge; he has been in the ark; he has seen a great deal; yet he is but a year and a half old. He will relate to you his history, which is extremely interesting."

"Go fetch your parrot," said Rustan, "it will amuse me till I again find myself disposed to sleep."

"It is with my sister, the nun," said Topaz; "I will go and fetch it. It will please you; its memory is faithful; it relates in a simple manner, without endeavoring to show wit at every turn."

"So much the better," said Rustan, "I like that manner of telling stories."

The parrot being brought to him, spoke in this manner:

N. B. Catherine Vade could never find the history of the parrot in the commonplace-book of her late cousin Anthony Vade, author of that tale. This is a great misfortune, considering what age that parrot lived in.

Dedalus European Classics

THE GOLEM — Gustav Meyrink

'The Cabala . . . found in the ghettos a suitable home for its strange speculations on the nature of God, the majestic power of letters and the possibility for initiates of creating a man in the same way God created Adam. This homunculus was called The Golem . . . Gustav Meyrink uses this legend . . . in a dream like setting on the Other Side of the Mirror and he has invested it with a horror so palpable that it has remained in my memory all these years.'

Jorge Luis Borges

"What holds us today is Meyrink's vision of Prague, as precise and fantastic at once as Dickens's London or Dostoevsky's St. Petersburg."

Times Literary Supplement (1970)

When *The Golem* first appeared in book form in 1915, it was an immediate popular and critical success, selling hundreds of thousands of copies. It has inspired three film versions. Admirers of the book have included Carl Jung, Hermann Hesse, Alfred Kubin and Julio Cortazar.

LES DIABOLIQUES (The She Devils) — Barbey D'Aurevilly.

The publication of *Les Diaboliques in 1874 caused an uproar, with copies of the book being seized by order of the Minister of Justice as it was a danger to public morality. Scandal made the book an immediate success, a century later it is now firmly established as a classic and studied in French Schools.*

"The book is a celebration of the seven deadly vices and shows no counterbalancing interest in the seven cardinal virtues. Even more, it is a celebration of pride, the pride of the ancient aristocracy of evil. Those who have the style to carry off their vices have also the right to do so."

Robert Irwin

"*Les Diaboliques* is intended to be a collection of tales of horror and this horror is, in each case, well built up and sustained."

Enid Starkie

LÀ-BAS (Lower Depths) — J. K. Huysmans

Là-Bas follows immediately on from *A Rebours* (Against Nature), and takes Huysmans' quest for the exotic and extreme situations a stage further. The novel's hero Durtal, investigates the life and times of the fifteenth century sadist, necromancer and child-murderer Gilles de Rais. But these dabblings, and table talk of

alchemy, astrology and spiritualism lead him on to direct experience of contemporary devil worship and sexual magic.

Bizarre and blasphemous, *Là-Bas* is even so a lightly fictionalised account of Huysmans' own experience in fin de siècle France. It is a classic work of fiction on nineteenth century Satanism and establishes Huysmans' reputation as one of the major novelists of his century.

BLANQUERNA — Ramon Lull

Blanquerna was the first novel to be written in any Romance language. It is a masterpiece of Catalan Literature by Ramon Lull, the thirteenth century mystic, philosopher, crusade propagandist and martyr.

"Lull was a universal genius, a bold anticipator of the thoughts and the problems of the future."

Friedrich Meer

"His fictional works contain such startling and imaginative conceptions that they have become an imperishable part of early Spanish literature. Chief of these books is *Blanquerna* a kind of Catholic *Pilgrim's Progress*.

Martin Gardner

Written a century before *The Canterbury Tales* and a century and a half before *Tirant Lo Blanc*, *Blanquerna* embodies a medieval dream of mysticism and chivalry.

THE LATE MATTIA PASCAL — Luigi Pirandello

Nicoletta Simborowski's new translation of *The Late Mattia Pascal*, will help re-establish Pirandello's reputation as not only a great playwright, but one of the 20th century's greatest novelists.

Published in 1904 the novel marks the beginning of his preoccupation with the relativity of human personality, and his break with verism, and the style of Verga.

Impoverished and unhappily married Mattia runs away to Nice and wins a fortune at the Monte Carlo gaming tables, but despite his new found wealth still feels the need to return home. On the train home he reads in his local newspaper that the body of a drowned man has been identified as the missing Mattia Pascal, and he is officially dead. He still returns home, where he finds his wife remarried, and takes up his old job in the library, living the life of the late Mattia Pascal.

LA MADRE (The Mother) — Grazia Deledda

Grazia Deledda is one of the most important women writers of the twentieth century. Her depiction of the primitive and isolated communities of northern Sardinia in a perceptive, intense and individual style gained her the Nobel Prize for Literature in 1927.

"The interest in *La Madre* lies in the presentation of sheer instinctive life. The love of the priest for the woman is sheer instinctive passion, pure and undefiled by sentiment. The instinct of direct sex is so strong and so vivid, that only the blind instinct of mother obedience, the child instinct, can overcome it."

D. H. Lawrence

I MALAVOGLIA (The House by the Medlar Tree) — Giovanni Verga.

I Malavoglia is one of the great landmarks of Italian Literature. It is so rich in character, emotion and texture that it lives forever in the imagination of all those who read it.

What Verga called in his preface a "sincere and dispassionate study of society" is an epic struggle against poverty and the elements by the fishermen of Aci Trezza, told in an expressive language based on their own dialect.

The lyrical and homeric qualities in Verga are superbly brought out in Judith Landry's new translation, which will enable a whole new generation of English readers to discover one of the great novels of the 19th Century.

"A great work" *D. H. Lawrence*.

"*I Malavoglia* obsessed me from the first moment I read it. And so when the chance came I made a film of it. 'La Terra Trema'" *Luchino Visconti*.

SHORT SICILIAN NOVELS — Giovanni Verga
(translated by D. H. Lawrence)

"*Short Sicilian Novels* have that sense of the wholeness of life, the spare exuberance, the endless inflections and overtones, and the magnificent and thrilling vitality of major literature."

New York Times

"In these stories the whole Sicily of the eighteen-sixties lives before us — poor gentry, priests, rich landowners, farmers, peasants, animals, seasons, and scenery; and whether his subject be the brutal bloodshed of an abortive revolution or the simple human comedy that can even attend deep mourning, Verga never loses his complete artistic mastery of his material. He throws the whole of

his pity into the intensity of his art, and with the simplicity only attainable by genius lays bare beneath all the sweat and tears and clamour of day-to-day humanity those mysterious 'mortal things which touch the minds'."

Times Literary Supplement

MASTRO-DON GESUALDO — Giovanni Verga
(translated by D. H. Lawrence)

On the face of things, Mastro-Don Gesualdo is a success. Born a peasant but a man "with an eye for everything going", he becomes one of the richest men in Sicily, marrying an aristocrat with his daughter destined, in time, to wed a duke.

But Gesualdo falls foul of the rigid class structure in mid-19th century Sicily. His title "Mastro-Don", "Worker-Gentleman", is ironic in itself. Peasants and gentry alike resent his extraordinary success. And when the pattern of society is threatened by revolt, Gesualdo is the rebels' first target . . .

Published in 1888, Verga's classic was first introduced to this country in 1925 by D. H. Lawrence in his own superb translation. Although broad in scope, with a large cast and covering over twenty years, *Mastro-Don Gesualdo* is exact and concentrated; it cuts from set-piece to set-piece — from feast-day to funeral to sun white stubble fields — anticipating the narrative techniques of the cinema.

CAVALLERIA RUSTICANA — Giovanni Verga (translated by D. H. Lawrence)

"these stories must be rated among the best produced in Europe in the last century."

Giovanni Cecchetti

"*Cavalleria Rusticana* has that sense of wholeness of life, the spare exuberance, the endless inflections and overtones, and the magnificent and thrilling vitality of major literature."

New York Times

"complete artistic mastery".

Times Literary Supplement

The publication of *Cavalleria Rusticana* means that all Verga's major works are now available in English from Dedalus.